HOW TO LOOK AT PHOTOGRAPHS

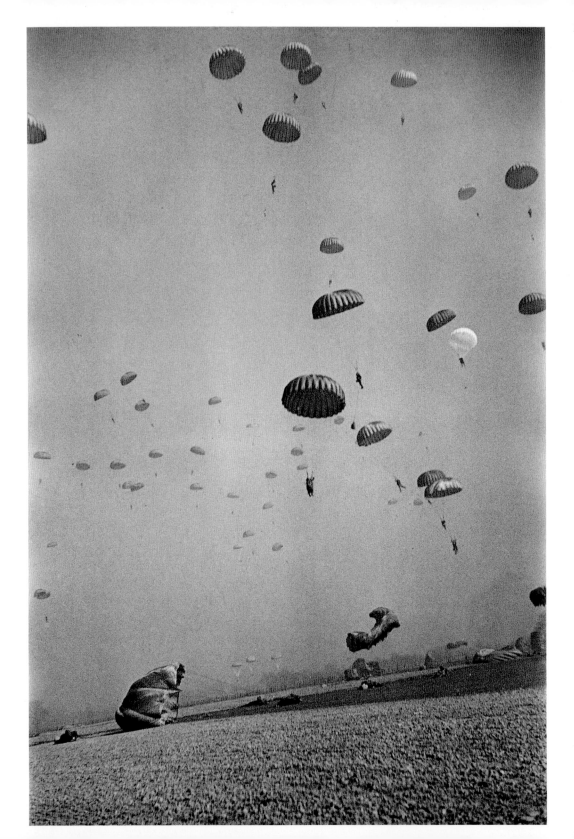

HOW TO LOOK AT PHOTOGRAPHS

Reflections
on the
Art of Seeing

BY DAVID FINN

Harry N. Abrams, Inc.,
Publishers

Editor: Beverly Fazio Herter
Art Director: Michael Schubert
Designer: Chris Gorney
Photo Research: Neil Ryder Hoos

Library of Congress Cataloging-in-Publication Data

Finn, David, 1921–
How to look at photographs:
reflections on the art of seeing / by David Finn.
p. cm.
ISBN 0- 8109–2553–2
1. Photographic criticism. I. Title.
TR187.F55 1994
770'.1— dc20 93–6354

Published in 1994 by Harry N. Abrams, Incorporated, New York
A Times Mirror Company
Printed and bound in Hong Kong

Photograph credits:
The author and publisher would like to thank all those who provided photographs for this book,
including the following: frontispiece: © Robert Capa; pp. 11, 37, 93: © Ralph Steiner; p. 12: Keith
Bloomgarden; p. 18: © Janice Mehlman; p. 19: © Gordon Parks; p. 26: Collection, The Museum of
Modern Art, New York. The Abbott-Levy Collection. Partial gift of Shirley C. Burden; p. 27: ©
Marcel Imsand; p. 29: © William Rivelli; p. 30 below: © Ernest Haas; p. 34: Henri Cartier-
Bresson\Magnum Photos Inc.; p. 38: © David Morowitz; p. 39: Noah Finn; p. 46: © John Pfahl; p. 47:
David Leslie; p.48 AP\World Wide Photos; p.49: © 1981 The Heirs of W. Eugene Smith\Black
Star; p. 50: The Metropolitan Museum of Art, New York. The Alfred Stieglitz Collection, 1949; p. 55:
The Art Institute of Chicago, Alfred Stieglitz Collection, 1949.742. © 1993, The Art Institute of
Chicago. All Rights Reserved; p. 56: © Yvonne Halsman; pp. 59, 61, 75: © Yousuf Karsh; p. 62: ©
Helen Marcus; pp. 77, 83, 103: Library of Congress, Washington, D.C.; p. 78 top: Paul Edwards; pp.
78–79: © Frederick Brenner; pp. 83, 100, 120: Courtesy George Eastman House; p. 84: © Cornell
Capa; p. 86: © 1971 Aperture Foundation, Inc., Paul Strand Archive; p. 88: © The Aaron Siskind
Foundation. Courtesy Robert Mann Gallery, New York; pp. 91 right, 121: © 1981 Center for
Creative Photography, Arizona Board of Regents; p. 98: © Amanda George; p. 99: © Gregory
Paulson; p. 105: © Charles Phillips; pp. 114, 137: © William Baker; p. 115: © Harvey Lloyd; p. 116: ©
Gilman Paper Company Collection; p.125: Amy Binder; pp. 126, 135: Maurizio Ghiglia; p. 127:
Courtesy Estate of George Platt Lynes; p. 128: © The Estate of Robert Mapplethorpe; p. 129 top: ©
Robert Laurie; p. 129 bottom: © Deborah Turbeville; p. 130: The Art Institute of Chicago, Gift of
Richard Ryan, Jr., 182.1786. © 1993, The Art Institute of Chicago. All Rights Reserved; p. 134 ©
Barbara Morgan; p. 137: Charles Lipton.

Front cover: (Background photo) David Finn. *Crystalline Sky*. 1990. (Insert photos, clockwise from
upper left) Dorothea Lange. *Migrant Mother* (detail). 1936. David Finn. *Skyline at Sunset*. 1980s. Ernst
Haas. *Untitled (Wet Leaf)* (detail). 1963. David Finn. *Subway Scene*. 1982.

Back cover: David Finn. *Walking by the Cube*. 1985.

Frontispiece: Robert Capa. *U.S. 17th Airborne Division*. The Rhine. 1945.

Contents

Introduction

About thirty years ago when my wife and I visited Norway for the first time I became conscious of what the art of photography can contribute to our lives. We knew Norway as the land that had inspired the powerful and deeply moving novels of Knut Hamsun; the brooding, sometimes frenzied paintings of Edvard Munch; the haunting, beautifully melodic musical compositions of Edvard Grieg. They seemed to create a composite picture of a strange and beautiful country that we yearned to see for ourselves. We didn't consider this a sight–seeing tour of fjords and snow-topped mountains, so photography was definitely not on our minds as a priority. Moreover neither of us knew anything about cameras. But we did take a newly purchased Polaroid camera with us just in case we saw something we wanted to photograph as a memento of our trip.

The land of Hamsun, Munch, and Grieg fully lived up to our expectations, and we fell in love with their Norway. But one of the highlights of our trip was something we had never heard about before. We came across a place called Frogner Park in Oslo that was filled with an astonishing collection of sculptures by a Norwegian artist named Gustav Vigeland. There were literally hundreds of life-size naked figures in the park—children at play, mothers and fathers with their children, young lovers, old lovers, grandmothers and grandfathers with their grandchildren, people with animals. Some figures were incredibly tender, others were warm and romantic, still others were highly energetic—even wild. They seemed to run the gamut of human relationships in what the sculptor called "The Cycle of Life." They also ran the gamut of sculptural mediums, with bronze sculptures mounted on a bridge and around a fountain, stone sculptures on a large, stepped plaza, a tall monolith with writhing figures climbing or floating upward, and wrought-iron gates with life-size figures drawn in outline. There was a museum in the park filled with original plaster models and maquettes—all by this

David Finn.
Embrace of Life.
Oslo, Norway. 1962

7

unknown (to us), strange, and passionate artist who had in his own way presented his unique version of the Norwegian spirit.

We tried to buy a book with photographs of Vigeland's sculptures, but at the time there was none to be had. So the next day we went back to the park with our Polaroid camera to photograph as best we could some of those remarkable figures. I carefully aimed my camera so that I could catch the spirit of the sculptures and show the lovely Norwegian landscape in the background.

Months later, Harry Abrams, the publisher, happened to see in my office some enlarged prints I had made from my Polaroid pictures. "What are those?" he asked, curiously. I told him about Vigeland and Frogner Park, and he was obviously impressed. "We should do a book on Vigeland," he said, to my delight. "You should, by all means," I replied. "No, *we* should," he insisted. "You take the photographs and I'll publish the book!" I thought he was kidding, although I was pleased by the implicit compliment. "I'm not a photographer," I said, stating what I thought was the obvious. "Oh yes you are," he insisted. "You have an eye, and that's the secret of being a good photographer. Go back to Oslo, photograph all the sculptures in the park and the museum, and we'll do a book together."

I did, he did, and *Embrace of Life*, my first of more than forty-five books of photographs, was born. So also was the beginning of my wonderful adventure in the art of seeing. Not that I was blind to the world around me before I had a camera glued to my eye, but I have seen so much more through that magic piece of glass that I consider its acquisition the beginning of a new era in my life.

Thirty years later I have taken tens of thousands of photographs, most of them with my ever-growing collection of Hasselblad camera equipment. I have discovered more every day about how the camera can teach me to look with a penetrating eye at everything that comes into my field of vision. I have learned what it means to experience revelations when I focus my attention on a particular part of the world around me or when I look at photographs that reveal some essence of that world.

David Finn. Spring. New Rochelle. 1980

This book has been written to share those revelatory experiences and to help you discover what the eye of the photographer can teach you. You may become an inspired photographer after reading this book, or become a collector of photographs, or become a more appreciative visitor to photographic exhibitions in museums and galleries. Any of these will have made this book worthwhile. But even more important is the hope that your life may be enriched by the art of seeing, which you can learn from the photographer's eye.

You can experience the art of seeing while looking out at the ocean from a high point on the shore — perhaps the top of a hill or even a hotel window. If you stare at the water you see nothing but the sea with little ripples in it, and on the shore perhaps a strip of beach. But if you happen to see two figures standing on the shore as photographer Ralph Steiner did many years ago, looking tiny as they peer into the wide expanse in front of them, their little shadows forming a sort of base on which they stand, you will have a sense of the unimaginable vastness of the earth and our smallness as its inhabitants.

Ralph Steiner was a dear friend as well as a great photographer, and this was the first photograph by him that I ever saw. Shortly after we met many years ago he decided to make up a large number of prints of the photograph for his Christmas card, and since I was doing graphic design at the time, he asked me to help create the card. I thought it was a fine idea and was glad to do so. When I became a serious photographer myself, Ralph was always there, both to encourage and to guide me. One of his most inspired ideas was to teach people the art of seeing, and in later life he made a series of films showing how beautiful the things we see everyday can be — water in a lake glistening in the sun, clothes hanging on a line and blowing in the wind. He was ebullient as ever when he died in his eighties; he would have been thrilled to know that I was writing this book, which reflects so much of what I learned from him.

You can experience the art of seeing when you look at the branches of a tree in winter. The forms of the branches seem

**Ralph Steiner.
Two Men and
the Ocean. 1921**

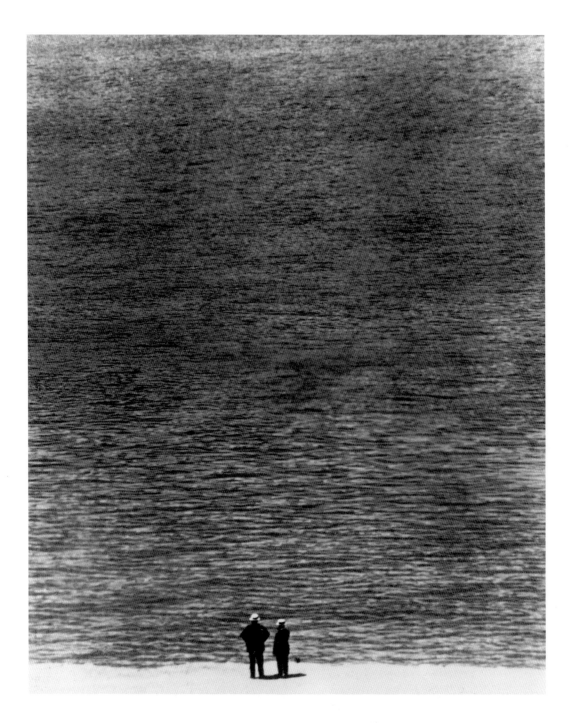

particularly strong and vibrant when they are bare and not cov-
ered with leaves. Perhaps you feel as the sculptor Henry Moore
did on his daily walk on the grounds around his house when he
passed by one of his favorite trees and admired its twisting, turn-
ing sculptural forms. I once asked him if he didn't like the tree
better in the summer with leaves on it. "Not at all," he replied
firmly. "When it has leaves on it looks like cabbage!" Cézanne,
whom Moore revered, would have felt differently; he saw abstract
forms in the leaves of the trees and created some of his great
paintings with his unique brushstrokes. As a photographer, my
favorite time of the year is spring, when one can see the branch-
es bejeweled with budding leaves (p. 9).

When my granddaughter Rachel was given her first camera at
the age of seventeen, she became fascinated by a tree on the shore
of a small lake near her house. She spent hours photographing its
reflections below, its twisting branches above, sometimes climbing
up to the limbs and catching different views from new vantage
points. One day she went out to the lake and discovered to her dis-

**Keith Bloomgarden.
Hidden Reflections.
New Rochelle. 1993**

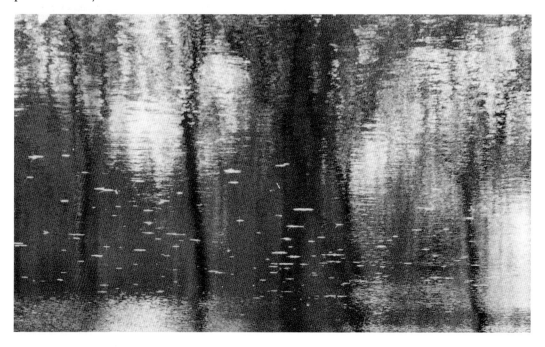

may that the tree was gone. It had been cut down, she learned, because some parents had feared that their young children might climb out on its limbs and fall into the water. She felt as if her tree had been senselessly murdered, and was heartbroken. She enclosed some of her photographs of the lost tree as part of her college application essay, and when she was accepted at her college of choice, she was sure her tree had helped her.

The next year, Rachel's younger brother, Keith, went back to the lake with his camera. A friend of his had just been killed in a bizarre bus accident, and he spent the afternoon trying to express his sorrow with his camera. Afterward, he wrote an essay that included this passage:

> I remember the tree that used to be here and almost cry. A beautiful twisted tree that stretched out over the lake. Last year it was killed because the family across the street was scared their children would fall into the water. So now it is gone but I remember what it used to be and begin taking pictures. The trees are full of leaves just like the old twisted tree. Click, click. I look at their reflections in the water. That is where another picture is hidden. I take pictures furiously. The camera steals the moment again and again. I wonder whether the pictures will come out, I always do.

The camera helped Keith *see* more, despite his uncertainty about the results. He was grateful that some of his photographs did "come out." There was one especially sensitive photograph of the Monet-like surface of the lake that expressed in a mysterious way the mood he had been in. As with his sister, the camera captured some of the feeling that moved him so deeply.

You can practice the art of seeing in the most common, every day experience, such as looking at the sky when rays of the sun are streaming through dark clouds. Everything changes as the clouds move, and you are mesmerized.

Alfred Stieglitz began photographing clouds as a young man; he called these photographs "Equivalents" because he believed they conveyed his subjective emotional and psychological experiences. Ralph Steiner came to photograph clouds when he was in his eighties, and it was hard for him to walk around. "I soon discovered," he once wrote, "that clouds had many and very differ-

ent things to say—their personalities were so varied. The vastly differing personalities kept me on my creative toes, trying to photograph so that each cloud would say in print what it had said to me when floating across the sky."

Clouds are among the few forms we know that are constantly changing and entirely unpredictable. Although we have learned to categorize them into different types, each cloud has its own private destiny. Many of us have watched clouds for hours while lying on the grass or on the beach. Catching this evanescent form on film, making permanent something that exists only for a passing moment and then is gone, is one of the camera's great accomplishments. It is like photographing the wind in the trees which the Greek poet George Seferis saw as a metaphor for the words of man in one of his "Secret Poems":

> As pines
> keep the shape of the wind
> even when the wind has fled and is no longer there
> so words
> guard the shape of man
> even when man has fled and is no longer there.

On an airplane trip I am often mesmerized by cloud formations I see from above, a scene our ancestors could never have even imagined. I think of how Leonardo da Vinci would feel if he could be in the flying machine he dreamed of and which has become such a commonplace for us, and could look down on the clouds from the sky. Another spectacular view from above the clouds that was unknown to our ancestors is the sight of a brightening sky at dawn with the incredible blue color of the sky taking one's breath away. I always think of Mark Rothko's paintings when I see such sights and wonder if he was inspired by airplane views or intuitively felt the colors that our century was the first to witness.

You can experience the art of seeing when you visit the grade schools that your children or grandchildren attend, and you see all those bright, cheerful faces of youngsters having a wonderful time. Not long ago I took a series of photographs for a book on the United Nations International School in New York, where

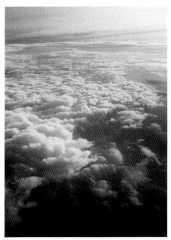

**Above: David Finn.
Leonardo's Dream.
Flight to Chicago. 1991**

**Opposite: David Finn.
Crystalline Sky.
Transatlantic flight. 1990**

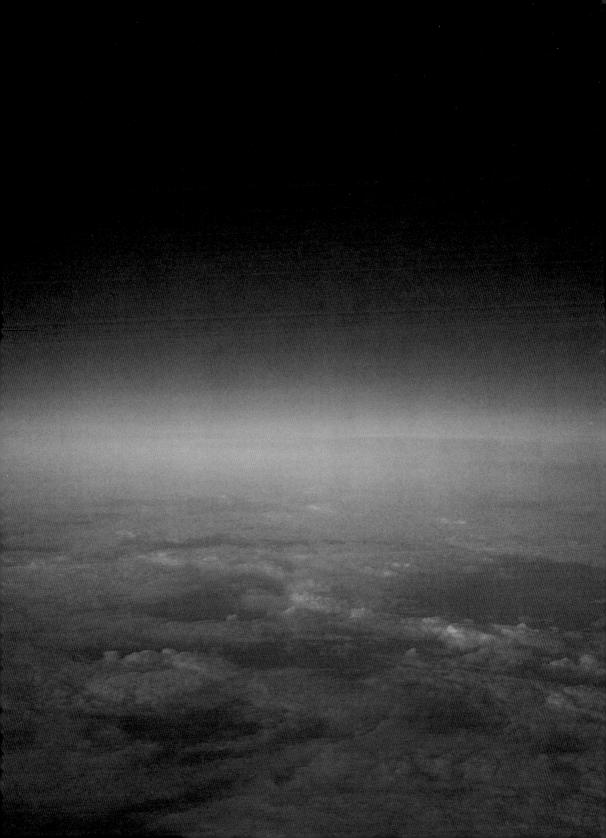

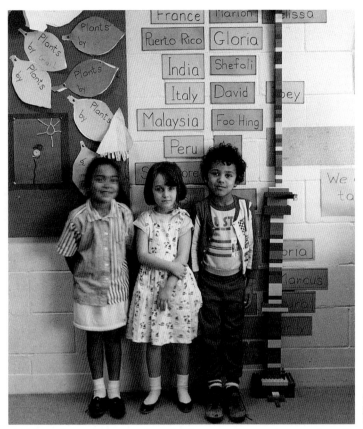

David Finn.
Children of the World.
New York. 1989

children from over one hundred countries study together. In one class there was a list of countries from which the students came, together with the names of the children, posted on a wall, and three of the youngsters wanted their picture taken in front of it. I was delighted, and even though one of the children was moving and her face was slightly out of focus, I think the photograph tells a lovely story. Photographs that catch the spirit of happy children who enjoy being photographed are infectious and convey a sense of freshness and joy of life.

There are, of course, many techniques by which photographers can exercise some control over the photographic process. Skill in lighting can sometimes be crucial, and photographers may pay a lot of attention to the way the light falls in order to achieve a

desired effect. The size and type of film used, the setting of the aperture opening that determines the depth of field, the speed at which the shutter is opened and shut—all can affect the quality of the result. There are many kinds of lenses, filters, extension tubes, and other equipment that can make a major difference in the way a photograph is taken.

Work done in the darkroom in the development of negatives and prints also provides major creative opportunities. Black-and-white photographs generally provide more latitude in this respect than color photographs. One can lighten a part of the print by blocking the light from the enlarger (called "dodging") or darken it by exposing it longer (called "burning"). One may use different solutions in the developing process to achieve different effects. Settings of the enlarger and length of exposure as well as developing time can produce varied results. Photographers sometimes spend a whole day or more working on one negative, making many trial prints before achieving the final print that satisfies them.

The impact of a black-and-white print thus can be greatly enhanced by the skill of the printer. This is an aspect of photography of which many laypersons may not be aware, and there is a widespread misconception that black-and-white photographs are more primitive than color photographs. But black-and-white photographs should more properly be compared to drawings, etchings, and lithographs, which are different from but no less worthy than paintings.

There is undoubtedly a place for both. In some respects black-and-white photographs are more "real" than color photographs because they represent the subject without embellishment. They speak more simply and directly to the viewer, and their images somehow appear to be more authentic. In other respects color photographs are more "real" because they are closer to what we actually see. The colors show texture and vibrancy and delight the eye with the richness of contrasts and harmonies found in the spectrum.

Through their experiences and experiments photographers have discovered that there are different realities they can portray

with their cameras. This has less to do with the development of new technologies than with the essential nature of the photographic process. And the pictures they produce can sometimes be a far cry from the way the world looks to the naked eye.

For instance, Jerry Uelsmann superimposed several negatives on top of one another in a process he calls "postvisualization," by which he means "the willingness on the part of the photographer to revisualize the final image at any point in the entire photographic process." He created surreal images by performing a "form of alchemy." He once wrote that his experience in the darkroom "seems to relate to an internal/external cosmology ... a turning inward relative to what has been discovered outside."

Some artists go beyond the darkroom and merge the photographic image with other techniques. There are those who make paintings of photographs, while others integrate prints into their paintings. One artist, Janice Mehlman, takes photographs of details of architecture, makes large prints from her negatives, and then paints selected areas to create remarkable effects. She writes about her work:

> My photographs depend upon real space, from which I create abstractions of light, form and shape. Through photography, I am able to unify representation and geometry, the real world with the abstract, as I did with my photograph *Duality of Plane* taken in the

Janice Mehlman.
Duality of Plane.
Paris. 1992

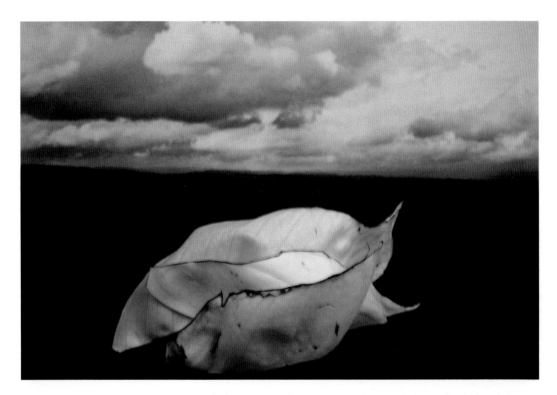

Gordon Parks.
Rain Clouds. 1993

George Pompidou Center in Paris. I then enhance the ambiguity between surface and receding architectural space, by painting selected areas of these black and white prints with thin washes of transparent color. The blacks, whites, and grays remain dense and rich, and the expressive character of the image is enhanced by a chromatic intensity and mystery. The fact that these abstractions begin as photographs of real existing space, also adds to their mystery.

One of the most creative individuals of our time is Gordon Parks — photographer, painter, poet, musician, film producer, novelist. He excels in every one of those mediums and has produced great works of art in several of them. Recently he worked on a long novel based on the life of the painter J. M. W. Turner. In the course of the seven years he devoted to that project, Gordon spent some time at the Tate and Clore galleries in London and became fascinated by the delicate hues and masterly brushwork of Turner's watercolors. He decided to try some watercolors of his own in the Turner tradition (previously he had only painted in oils), and

he produced some remarkable results. When his ex-sister-in-law saw his new paintings she thought they were lovely but felt that something was missing. That comment stuck in Gordon's head, and suddenly he had an idea. How about taking random objects— a shell, a leaf, a stone, an eggshell, the skeleton of a fish — and juxtaposing them with his watercolor landscapes; he would then photograph the combination of object and painting to create a new kind of work of art. He tried many variations with different watercolors, and the results were astounding. As time went by, he produced dozens of the most exquisite photographs with an almost endless variety of common objects. Some photographs could be compared to Georgia O'Keeffe's finest paintings, others were worthy of Dalí at his greatest, or De Chirico. But most of all, they were distinctively Gordon Parks — mysterious, spellbinding, dramatic, powerful.

Gordon wrote some poetry to accompany the photographs and the whole series, called "Arias of Silence," is being published as a book by Little, Brown. One of his photographs was made with white petals taken from a flower; it looks like a strange form lying on the ground with a sky full of clouds painted with extraordinary sensitivity. Accompanying it is a poem entitled "I Will Be All Light."

Summer is done with me —
the leaf, the petal, the flower.
But all is not over.
My spirit grows boundless,
soaring without worry, without tiring
through the most wreckful storms.
I see through death and refuse it.
Having known the firmness
of branches and vines;
of so many suns and moons;
of every ennobling cloud flake,
I have at last learned to endure.
No lament for this season.
Peace jostles the space I share
with this cold wind blowing.
Summer has fallen silent,
but its virtues gather in waves
up here where harsh winds cry.

No winter tears. No parting sorrow.
I am meant to grace this world
that blessed me with such abundance and promise.
When this disgruntled season passes
I will wing my way back to you.
You will know me
by the fragrance on my petals.
Strewn along your footways
I will be all light.*

Notwithstanding the imagination and ingenuity of photographers who have forged new ground in creating photographic images, the heart of a photographic work of art is still a passionate eye looking through the camera lens. If it is sometimes not the end of the photographic process, it is always the beginning.

If you find yourself fascinated by people you see while walking in the city or country, or you gasp at a majestic view of a valley after climbing to the top of a mountain, or you are spellbound by a spectacular reflection in the still water of a lake, or you are captivated by the smile of a baby looking over her father's shoulder, you feel the same kind of uplifting experience that is provided by a great work of art. The difference is that what you have felt is gone the moment you turn your attention elsewhere, whereas artist/photographers have found a way to make their experiences endure.

You can be affected by their achievements when you are touched by a dramatic photograph in a newspaper or magazine, or a fine photograph in a fashion advertisement, or a great photograph in a museum collection. Once you become aware of what the photographic eye can contribute to your heart and mind, you will be adding an aesthetic dimension to your everyday life that will provide you with endless pleasures and rewards. You will have the benefit of what photographers can teach you to see through your own increasingly sensitive eye and through the images they have captured on film.

* Gordon Parks. *Arias in Silence*. Boston: Little, Brown, forthcoming 1994.

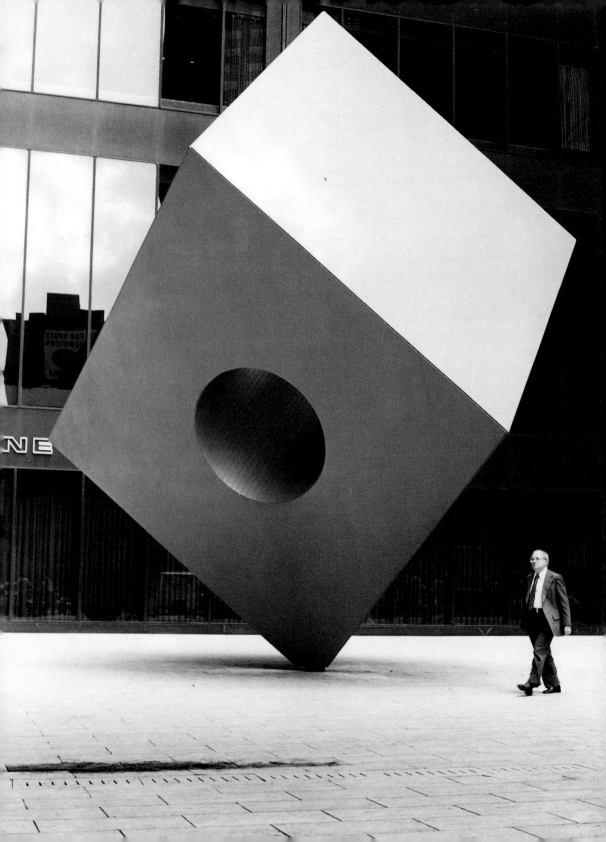

Discovery

To master the art of seeing you have to develop the ability to become emotionally involved in what you are looking at and learn how to identify the harmonies of shapes and forms and colors that contribute to your feelings. This advanced stage of perception is probably inborn in some individuals and needs to be cultivated in others. I believe it can be mastered by all.

The most primitive form of perception merely records the infinite number of nuances in our field of vision the way the camera does on film. No intelligence intervenes to interpret what has been recorded. We can only imagine what that is like since our eye is educated to see in a different way. The form of perception that we are used to converts those nuances into recognizable objects as we look at the world around us. We know that what we are looking at is a tree, a house, a person. The art of seeing, however, is on a higher plane; it enables us to discover the character of an object or a relationship between objects that moves our emotions and excites our aesthetic sensitivity. When we experience the art of seeing we may be in effect creating a picture of something beautiful or compelling or delightful in our mind's eye.

Some years ago, the author William Saroyan contributed some words to accompany a book of photographs about America by Arthur Rothstein. In his introduction, Saroyan wrote:

> It is in our nature to look and see. We thrive in this luxury—this never-ending feast. The more we look the more we see, the more we want to look, and the more there is to see, and the more fine points there are to discover in everything it is possible for us to see. A daisy is a simple flower until you begin to really look at it. A good photograph of a daisy will impel you to start looking at a real daisy more pointedly, and from that looking at all things more pointedly. . . .*

The gift which the invention of the camera has given to millions is the ability to reproduce accurately something they see that gives them pleasure, a feat once reserved for those skilled in the techniques of drawing, painting, or sculpture. Photography

David Finn.
Walking by the Cube.
New York. 1985

*William Saroyan and Arthur Rothstein. *Look at Us*. New York: Cowles Book, 1967.

in that respect has democratized the process of reproduction. However, mere reproduction is not sufficient for a work of art; something more is needed. That something is the ability to recognize what is worth reproducing.

The camera is a mechanical device with no brain of its own despite all the advanced electronics in the latest models that enable almost everything to be done automatically. It is simply the tool that allows photographers to create their works of art. The secret of their achievement is the ability to choose the decisive moment when a memorable image can be framed within the borders of a negative or transparency. In that way the camera becomes the instrument of their creative eye, the eye of their heart and mind. When they are struck by what they see at a particular moment and point their camera, not only paying careful attention to the persons or things they are photographing but being conscious of how they are composed in the viewfinder — as when I was able to release my shutter at the very second that a man was walking under the giant *Cube* sculpture by Isamu Noguchi in lower Manhattan (p. 22)—the image which appears on film may be equally striking to others.

A landmark in the art of pointing one's camera with care and precision was achieved by a French photographer, Eugene Atget, who lived from 1856 to 1927. Atget was a quiet, unassuming, modest man who made a meager living as a commercial photographer. But in the course of his life he produced some ten thousand photographs of Paris and its environs, which proved to be a unique demonstration of how the camera enables one to make discoveries in the world around us. Atget apparently didn't have this as his goal, and from his point of view he was merely using his camera to document the era in which he lived. In 1920, he wrote to the director of France's Commission for Historical Documents, "I possess all of *Vieux Paris.*" He didn't realize, and others of his time were not aware, that his eye for picking out special views of "Old Paris" produced remarkably beautiful images and led to an historic contribution to the art of photography.

24

It was only because a young photographer of the time, Berenice Abbott, recognized Atget's volume of work as an extraordinary achievement that we have an opportunity to appreciate his photographs today. Her portrait of him taken just before he died in 1927 shows how much she respected this unassuming man, who looks no more distinguished than the subjects he photographed. After Atget died, Abbott managed to save his life's work from destruction by purchasing his photographs from his executor. Many years later the collection was given to the Museum of Modern Art in New York, which in the early 1980s mounted an unprecedented series of four exhibitions, one each year, accompanied by a four-volume publication. It was then that the world of photography became fully aware of what Atget had accomplished.

In his introduction to the first volume John Szarkowski, curator of photography at the Museum of Modern Art, compared Atget's camera eye to the art of pointing. You see something remarkable and point it out to someone else so that another can see what you have seen, Atget pointed his camera to places and things he would like others to see, many of which were simply doors, beds, staircases, trees, street scenes (curiously the street scenes were often without people since he tended to take long exposures and the people moving on the street became invisible). In effect, he captured presences. He saw what was there, anywhere, and his camera gave that moment a place in eternity.

One discovers in an Atget photograph that Atget has seen something of great simplicity and pristine beauty in a place that any one of us might have passed without giving a thought to what was there. He can discover a fine composition in a staircase with an iron railing, and in a curving lamp hanging on the opposite side. In a garden scene with a pond or lake he photographed huge black shapes of the trees against the sky reflected in the water below—with the combined forms creating a strange, haunting composition that once seen in a print is unforgettable.

One hesitates to speculate about the *meaning* of these and other Atget photographs. There does seem to be something mys-

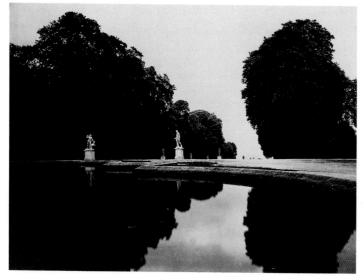

Eugene Atget.
St. Cloud.
St. Cloud, France.
1915–19

terious in them, something unstated—or understated—but ulti-
mately they are simply how the photographer looked at his
world. It is typical of Atget to show a corner of a room, or a part
of a chair, or a section of a window, or the door of a house, or the
trunk of a tree without worrying about the whole scene. He
didn't feel he had to show everything about the place in his
photograph; he just wanted to tell that special something that
attracted his eye and that he could frame in his camera lens.

Not long ago I visited the studio of a photographer in Lau-
sanne, Switzerland, who reminded me of Atget. His name is
Marcel Imsand, and his studio is on the top floor of a small
walk-up building. The place is tiny, with barely enough room to
sit down, but he showed me extraordinarily sensitive pho-
tographs of people and places that he had taken in connection
with various projects, both professional and personal. Imsand
had just returned from Russia where he had taken photographs
of people on the street and in the countryside for his own
interest. He was particularly pleased with a photograph that he
had printed the previous evening, explaining that it was the
only print he had made that evening, and had worked on it for
several hours. He gave me a present of several of his books and

I was especially touched by one of them. The book, called *Paul et Clemence*, was a series of photographs of two elderly people who lived together in a modest farm house. Imsand had photographed Paul one day when he saw him on a country road and got to know him. It turned out that many years ago Paul lived with his mother, and Clemence was a young woman working as mother's housekeeper. Paul was a scholar—an expert on Voltaire—and a musician who played piano all day, but he was totally impractical and never earned a living. There were chickens, rabbits, and bees kept on the farm, but Paul paid little attention to them. Before Paul's mother died she made Clemence promise that she would always take care of Paul, and she did so for over forty years. At one time Paul thought that perhaps they should get married, but they never did. As far as Marcel could see, they lived together as brother and sister. Imsand visited them periodically (they practically never had any other visitors), and he photographed them over the course of time. Paul died before the book was published but saw the photographs Imsand had taken of them. Each photograph is remarkably evocative, revealing in an almost magical way the character of the two subjects. In one, Imsand shows Paul's hands clasped on

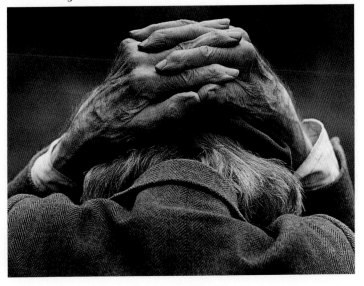

Marcel Imsand. <u>Paul</u>. Lausanne, Switzerland. 1970—75

the back of his head in what was apparently a characteristic gesture; it is not only a striking photograph of gnarled hands, it also gives one a sense of the nobility of a simple, earthy life.

The idea of choosing a theme for a particular project has intrigued many photographers. This may turn out to be a lifetime's work, as was the case with Atget and to some extent has been my own with my preoccupation of photographing sculpture through the ages. Or it may a special project like photographing the life of an individual—or two individuals—as it was for Marcel Imsand. The theory of all such themes is that the photographer learns to *see* more perceptively by concentrating on a particular subject over a period of time.

A good friend of mine, Bill Rivelli, developed a passion for photographing the interior of the Cathedral of St. John the Divine in New York City. Bill shares with me the blessing of having had Ralph Steiner as a teacher (because Ralph believed that all of life and everything we see is sacred, he often closed his letters with the words "the blessings" and added "St. Einer" after his signature). In 1977, Bill found himself in front of the cathedral and on an impulse decided to go inside. He happened to have a camera with him, and he couldn't help taking what he later called sketches of some of the striking details of the architecture. He was so intrigued by his black-and-white prints, that he subsequently went back with a large-format camera and a tripod and spent hours photographing different parts of the cathedral. This became something of a passion for him, and in the years that followed he made many excursions into the cathedral, photographing it again and again. This led to several exhibitions—the latest at the Municipal Art Society in New York in 1992. It was an adventure for Bill that he felt would go on indefinitely since he always found something new to capture through his camera eye.

André Kertész had a number of favorite themes; one of these, birds, led to a lovely series of photographs which he published in a small volume. I myself from time to time have photographed birds sitting on outdoor sculptures, which seem to be one of their favorite places. Usually they drive me crazy, since I

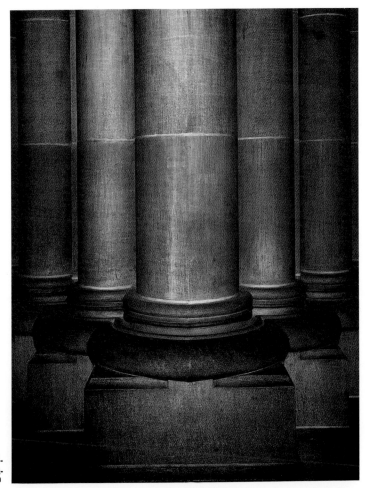

**William Rivelli.
Solid Columns.
New York. 1989**

want to photograph the sculptures without distracting intruders. But occasionally, I can't resist showing them in the picture, sitting or strutting around on their artistic perches. The results can be quite delightful, as in a photograph I took of one of the lions in front of the New York Public Library.

My photograph of that lion took on an added poignancy for me when the president of the New York Public Library, Timothy Healy, died suddenly in 1993. In a beautiful tribute to him, his assistant, Betsy Cahill, wrote:

His tenure at the Library was an almost perfect match of the person and the institution. Although he had more Fortitude than he had Patience, he loved both of the marble lions that guard the Library at 42nd Street. And he became in these three years the leonine presence to whom a City looked for leadership.

Sometimes a great photograph comes about in a moment of accidental discovery, as happened when Ernst Haas saw a magnificent golden leaf lying on the ground after an autumn rain. In this photographic tour de force everything about the image seems perfect: the colors and shapes of the water on the wet leaf, the color of the leaf itself, the curve of its graceful stem, the dark area around the leaf, the texture of the pavement, even the crack in the pavement that snakes up on the left.

Although I never met Haas, I owe the writing of this book to a series of television programs he had for many years, which he called "The Art of Seeing." Paul Gottlieb, the publisher of Harry

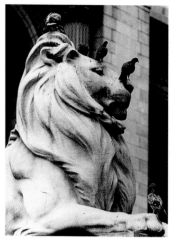

David Finn.
Library Lion.
New York. 1984

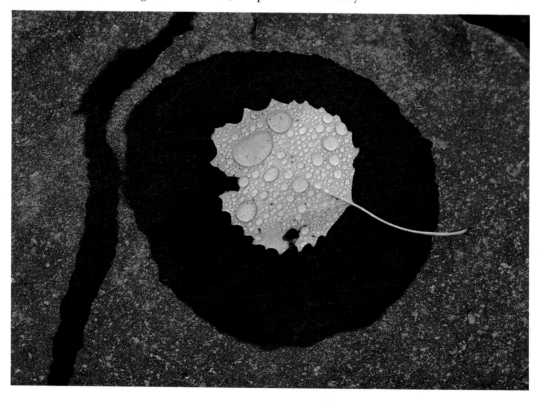

N. Abrams, Inc., remembered the programs as being particularly beautiful and moving, and he wanted Haas to write a book on the same subject. Unfortunately, Haas died before he had a chance to do so, and Paul suggested the idea to me. He thought it would be a logical sequel to two previous books I had written, *How To Visit a Museum* and *How To Look at Sculpture*. Haas had a genius for discovering beauty in the world around us, and he certainly would have written a book that would open readers' eyes to the majesty of everyday wonders. His photograph of the fallen leaf is a prime example of how a photographer's eye can pick out a wonderful detail in a magical moment of nature's continually changing world.

Some years ago, when Ralph and Caroline Steiner were gathering material for a book entitled *In Spite of Everything, Yes*, they paid special tribute to the Ernest Haas leaf photograph, featuring it on the jacket of the book as well as inside. The book contained poems and photographs that they considered affirmations of life, and accompanying the Haas leaf was a poem by Gerard Manley Hopkins:

> Glory be to God for dappled things—
> For skies of couple-color as a brinded cow;
> For rose-moles all in stipple upon trout that swim;
> Fresh-firecoal chestnut-falls; finches' wings;
> Landscape plotted and pieced—fold, fallow, and plough;
> And all trades, their gear and tackle and trim.
> All things, counter, original, spare, strange;
> Whatever is fickle, freckled (who knows how?)
> With swift, slow; sweet, sour; adazzle, dim;
> He fathers-forth whose beauty is past change:
> Praise Him.

Someone once said that any poem worth reading needs to be reread several times before its meaning begins to become clear. As one reads and rereads the Hopkins poem the words help the reader "see" ordinary sights in a new way. The vision is not only what the words describe but what one feels because of the way the words relate to one another. It's the combination of words, their rhythm, their sound (even when read silently), or what one senses in between the words, or behind the words, that stimu-

Ernst Haas.
Untitled (Wet Leaf). 1969

lates the mind and enables one to see something that might otherwise be invisible.

A photograph is deceptive in that regard. One tends to think that a quick look tells all, and that in that first instant the full meaning is disclosed. But it is as true with a fine photograph as with a fine poem that the more time one spends the more one discovers in it. In Haas's photograph, if you look closely you can see that the bubbles act like a magnifying glass, revealing the thin veins of the leaf underneath; that the delicate orange at the lower part of the leaf provides a subtle accent to the image; that the two indentations in the leaf's outline give emphasis to the evenness of the serrated edges; that the black area is a free-form oval that makes an ideal frame for the leaf; that the different hues of blue in the mottled pavement provide a soft and refreshing contrast to the rich gold; and that the pavement cracks in the upper left, center, and right of the photograph add elegant and unexpected touches to the composition. None of these details was made by the photographer (as would have been the case in a painting), but it was the photographer who realized that a wonderful image could be made by framing on film this particular piece of the world around him. One doesn't need to make such a thorough analysis of the photograph to appreciate its beauty; it can be sensed intuitively in a brief look. But through careful study the qualities that make it so remarkable become increasingly apparent.

One of the mysteries of the camera is that it enables one to see more in less—*more* aesthetic impact in the confined area of the viewfinder; *less* than what can be seen by the naked eye with its wide range of vision. It enables the photographer to look more closely at details and discover qualities that would otherwise be overlooked in the larger panorama. Training the eye to concentrate attention in a square or rectangular area transforms the vast world we see around us into discrete pictures.

The photograph also shows what can be seen in a fraction of a second, most often 1/60th of a second or less, rather than over a continuing period of time. In this respect it is markedly different from a video or film camera, which more closely resembles the

way the eye actually works. The photograph freezes an instantaneous vision, another example of less providing more. For in that minuscule period of time the photographer can record an enduring image which is fixed for all time.

Photographers master the art of seeing somewhat differently from other artists. Of course all artists need what Harry Abrams called "a good eye," but photographers have to attune their eye to the mechanical process of image making rather than the free hand of the painter or sculptor. Discovery is the key to the art of photography. It is not the handling of the pigment as it might be for a painter, nor the working on the surface texture in clay, wood, or stone as it might be for a sculptor, nor the arrangement of objects as it might be for a conceptual artist, nor the placing of stones or digging of ditches as it might be for an environmental artist. Those artists can redesign a scene, change forms into desired shapes, move objects around in different constellations. The photographer has to make do with what is there.

The work produced by a photographer is always based on what the camera reproduces mechanically on film. At the same time it is clear that photographers have many ways to express their individualities. Each photographer looks at the world with his or her own eye and achieves different results in the final photographic image. One can only imagine how differently Leonardo da Vinci, Michelangelo, Rembrandt, Delacroix, Turner, Van Gogh, Monet, Mondrian, Picasso, and Pollack would have used the camera, and how distinctive their photographs would have been. That same kind of distinction can be found in works by such great photographers as Cameron, Nadar, Steichen, Stieglitz, Strand, Kertész, Weston, White, Callahan, and Adams. They all use the same basic tools to produce their photographs, but their images are expressions of their individual personalities.

There can be a world of difference in the way one or another photographer shoots the same subject. What is crucial is what they see in their mind's eye in that magical instant when they decide to release the shutter. This is the supreme moment of creation for the photographer. Gary Winogrand had a passion to

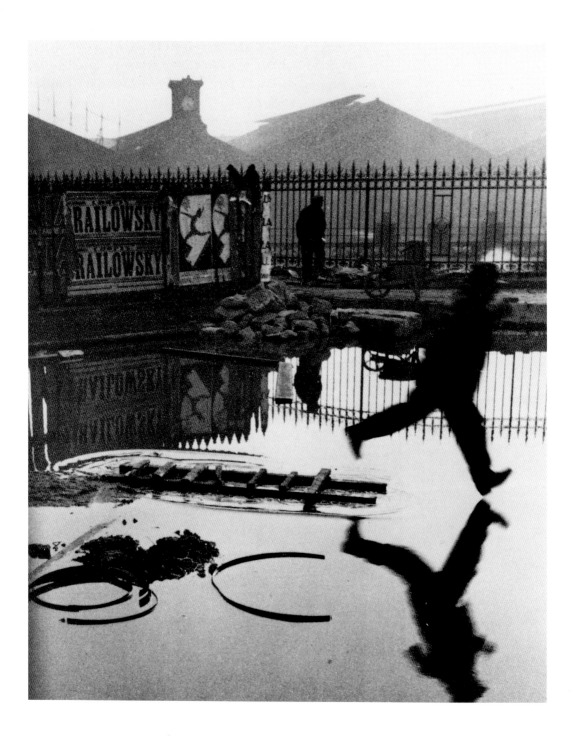

capture his "fragments from the real world" by snapping away feverishly with his camera to produce scenes from contemporary life—in the street, at parties, at airports, at press conferences— without much regard for composition or decorum. What is striking about his images is their freshness. He shows life the way it is, without interpretation by the photographer.

The master of such intuitive and spontaneous shooting was Henri Cartier-Bresson, who believed that what was seen in that decisive moment was the essence of photography. His eye was always on the lookout for things to come together:

> Sometimes it happens that you stall, delay, wait for something to happen. Sometimes you have the feeling that here are all the makings of a picture—except for just one thing that seems to be missing. But what one thing? Perhaps someone suddenly walks into your range of view. You follow his progress through the viewfinder. You wait and wait, and then finally you press the button—and you depart with the feeling (though you don't know why) that you've really got something.*

Cartier-Bresson's fleeting images of a busy world are the result of either genius or luck — or both — as they capture miraculously an image that others may treasure for years. Photographing a man running across a street on a rainy day, with his reflection showing in the puddle of water while he is still in the air, is for him the art of photography at its purest. He never cropped or otherwise modified his negative when making a print, because that seemed a violation to him. His image turns out to be beautifully composed because that is the way he trained his eye.

Although I do not personally practice the Cartier-Bresson theory and often crop my negatives to eliminate parts of the frame that I think are extraneous to the image I want to print, I do try to carry a pocket camera with me as often as possible so I can take advantage of fortuitous moments. Those unexpected opportunities make it seem as if photography is an easy art and that hard work is not required to produce outstanding results. But the ease with which a photograph is taken is deceptive. Learning to keep a sharp eye for telling images can take a lifetime of concentrated looking at the world to see what one can see.

Henri Cartier-Bresson.
Place de l'Europe.
Paris. 1932

*Henri Cartier-Bresson. *The Decisive Moment.* New York: Simon & Schuster, 1952

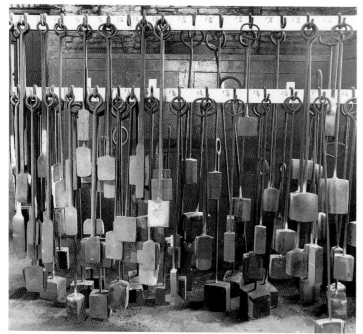

Sometimes photographers have to work like demons, taking rolls of film of the same subject before they find a few shots they feel are right. Haphazard and inexperienced pointing and shooting is not likely to produce a fine photograph. A snapshot can be taken by anybody. A work of art cannot.

It is always the unexpected which leads to discoveries. Anyone can be an explorer with the naked eye, but if one has a good reason to be in a particular place at a particular time with a camera, one can create images of those discoveries. I once was working on a book to commemorate the one hundredth anniversary of the Johnstown Flood, one of the most tragic natural calamities to have occurred in America. The book was called *Triumph of the American Spirit* because after two thousand people had been killed and an entire town virtually wiped out, the survivors pulled together magnificently and rebuilt their community. The story was also filled with pathos; the reason for the flood was the failure of a poorly constructed dam that had been made in order to create a recreational lake for rich tycoons who had made for-

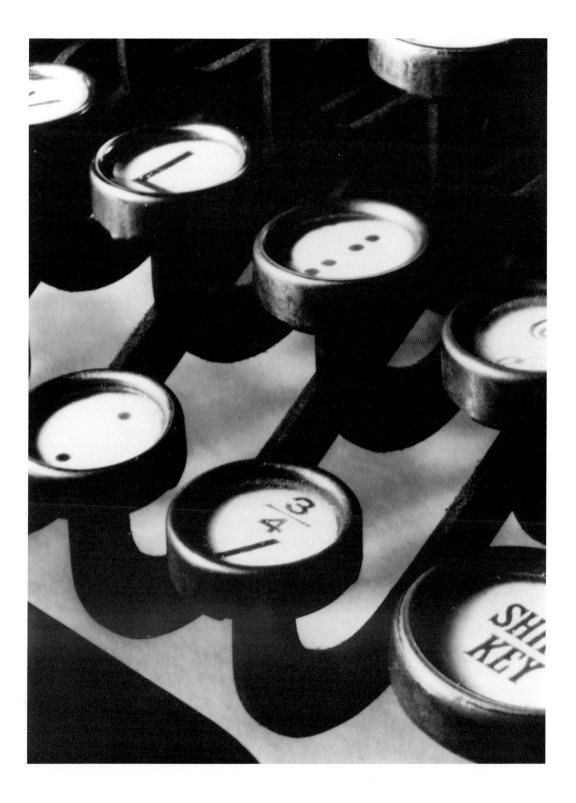

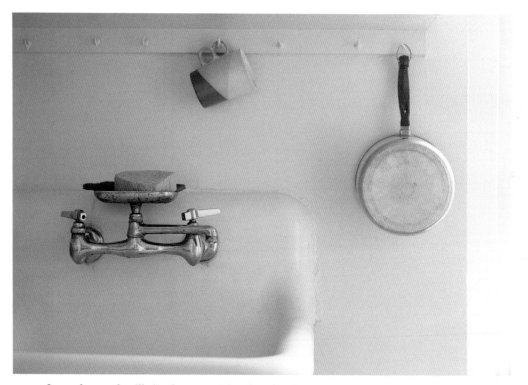

David Morowitz.
Kitchen for One.
Washington, D.C. 1992

tunes from the steel mills in the area. The dam broke and large numbers of the workers and their families were among those who drowned. While I was photographing in Johnstown I visited one of the old steel mills and my eye caught sight of some old tools hanging on a rack on a wall. These were ordinary blacksmith's tools and there were lots of them, memorializing the more than one hundred smithies who used to work there. They made a wonderful composition all by the purest of accident, but I photographed them as if they were a marvelously composed work of art.

A particularly touching photograph of simple objects, called *Kitchen for One*, was taken by David Morowitz, who is both a doctor and a photographer. When visiting the studio apartment of a ninety-year-old patient, a retired nurse, he saw a beautiful, random, asymmetric arrangement of the implements of solitary dining. He asked his patient's permission to photograph her

Noah Finn.
Construction Site.
Hunter, New York. 1993

kitchen, doing his best to explain why he found the combination of forms—the base of the pan, the horizontals of the cabinetry and sink, the geometry of the mug, the contrast of the sponge—irresistible. The photograph he took has an almost Shaker simplicity about it, with an inescapable sense of loneliness.

My thirteen-year-old grandson Noah is something of a prodigy with a camera. He took a photography class at school and has been obsessed with taking photographs ever since. After he had studied and practiced for a few months, we began to work together, and it was hard to tell who was the teacher and who the student. One day he showed me a print he had made of power tools sprawled on the floor, with wires curled in wonderful compositions. He was surprised when I told him how much I liked the composition of forms in his photograph—it all seemed so easy and obvious to him. Another time, he and I were walking in

Noah Finn.
Tree Sculpture.
Hunter, New York. 1993

a field and I pointed out the beautiful shapes of some abandoned tree stumps. "If you look through your camera viewfinder," I said, "you will find them to be as beautiful as a fine work of sculpture." He did, and snapped the shutter. He picked just the right detail, and the result was superb.

Other, more mundane objects have caught the eye of different photographers. Marcel Duchamp and Irving Penn were both intrigued with cigarette ashes; their photographs show how one can find surprising images in what many consider the most ignoble of nature's substances. Ralph Steiner's monumental photograph of typewriter keys is a superb example of his eye for finding beauty where it is least expected (p. 37).

I have had great pleasure in photographing the graceful forms of street lamps looking like birds stretching their long necks to see what there is to see. I've also enjoyed the abstract compositions created by stairs and their railings, and found a striking comparison in one of the magnificent Oscar Niemeyer buildings in Brasilia. But some of the discoveries that have made the greatest impact on me as a photographer are details of bridges and highways. As I am one of those who commutes to work every day by car, I have an opportunity to enjoy the beauty of those structures as I travel back and forth. Their forms are a constant source of amazement to me, and whenever I have been able to photograph one or another view I always feel as if I've been able to reveal a remarkable design that I find extraordinarily beautiful. One of my all time favorite shots is looking up from street level at the Bruckner Boulevard in the Bronx, with the various branches of the highway making a superb composition.

One can also find a striking pattern of lines and forms in the wood slats of a simple frame house. One such house caught my eye in Johnstown, Pennsylvania, and I took a number of photographs of it from different angles and focusing on different sections. The photographs I took of the whole house were quite dull, but one shot of a corner of the building, with just the edge of the roof showing, and with two windows and the top of the

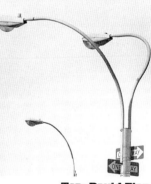

Top: David Finn.
Stairway.
Brasilia. 1992

Above: David Finn.
Talking Lampposts.
New York. 1985

Opposite: David Finn.
**Bruckner Boulevard
from Below**.
New York. 1984

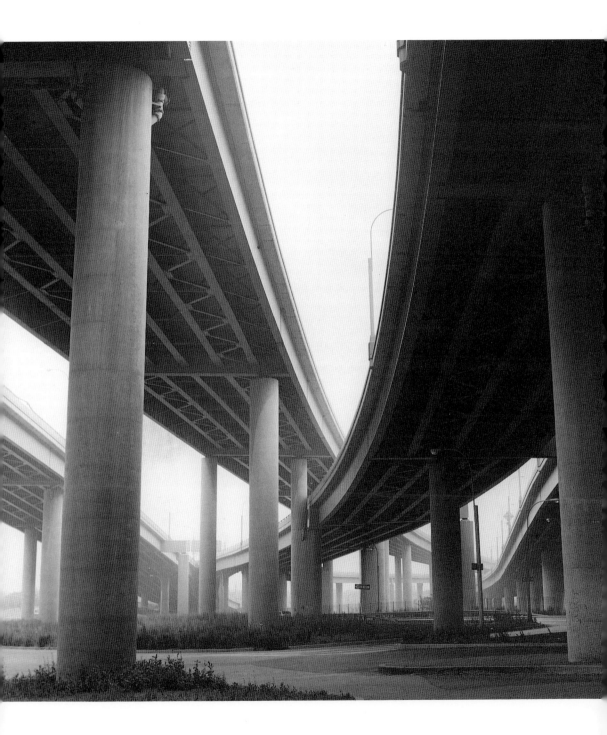

doorway providing accents for the strong horizontal lines, conveyed the feeling that had drawn my eye to the subject.

Stones are another marvelous subject for the camera eye. Renaissance artists were close observers of the subtleties of stone, as can be seen in Bellini's masterpiece *Saint Francis* in the Frick Collection in New York and Ghiberti's sculptured reliefs on the east door of the Baptistery in Florence. Many contemporary photographers are equally fascinated by stones as subjects, not to show an artist's skill at reproducing them but to show the beauty of stones in their natural state.

In Jerusalem, the great stones of the Western Wall tell stories of the ages as one stands in awe before them, watching the devout move back and forth in prayer. In Rio de Janeiro I found a variety of patterns in the stones sensitively arranged in superb gardens created by the world-renowned landscape artist Roberto Burle Marx for his own home. And in Kyoto, I saw stones in gardens and ponds looking like objects of great vener-

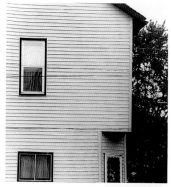

**David Finn.
House by the Railroad.
Johnstown,
Pennsylvania. 1985**

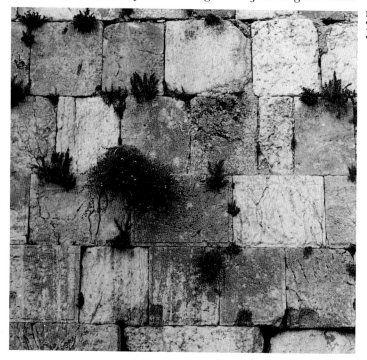

**Left: David Finn.
The Western Wall.
Jerusalem. 1968**

**Opposite: David Finn.
Stone Garden by
Roberto Burle Marx.
Rio de Janeiro. 1992**

ation. All of these confirm Thoreau's observation that "the finest workers in stones are not copper or steel tools, but the gentle touches of air and water working at their leisure with a liberal allowance of time."

The experience of personal discovery with a camera can be particularly rewarding when one visits a famous site that has been photographed by millions of others, usually with a friend or relative standing in the middle, to make a prized addition to a scrapbook. Postcards show popular views that have become clichés, and when you see those views with your own eyes you can't help but be as excited as everybody else by the mere fact of being there. But if you wander away from the crowd and look around you through your camera lens, you may enjoy the thrill of finding views that perhaps none of those millions of other sightseers ever saw.

David Finn. Water and Stone. Kyoto. 1973

This happened to me some years ago when my family visited Stonehenge for the first time. I had always been intrigued with the mystery of those ancient stones that had been transported over an incredible distance thousands of years ago to the plains of Salisbury, England. Much has been written about the astronomical function of the arrangement of the stones, marking the seasons like a giant calendar with openings through which the sun and moon and stars would rise in different parts of the horizon at different times of the year. There must also have been a religious significance to the overall structure, since it looks as if it might be the remnants of a great Celtic temple. But nothing I had read prepared me for the sublime feeling of being in its presence.

When we arrived at the spot I could hardly believe my eyes. At the time one could walk right up to the structure and wander around at will. Those giant, weathered stones seemed to have a character all their own. One could almost feel the presence of those who had brought them to this extraordinary place. I thought of T. S. Eliot's line, "Old stones that cannot be deciphered" (from Four Quartets), as a perfect description of that awesome combination of natural and man-made works of art.

David Finn. Stonehenge. Salisbury, England. 1978

I had a field day with my camera on that memorable visit, ferreting out views that showed the massiveness and mystery of the stones. They seemed to be arranged, either by design or accident, in such a way as to invite the exploring eye to make its own discoveries, and as I moved in and around them I kept finding images that I had never seen before in other photographs of the site. From one vantage point I saw a massing of stones that looked like a solid wall of a temple; from another I saw individual uprights in perfect harmony with each other, from others I saw views of slits of space between the stones, and from still others I

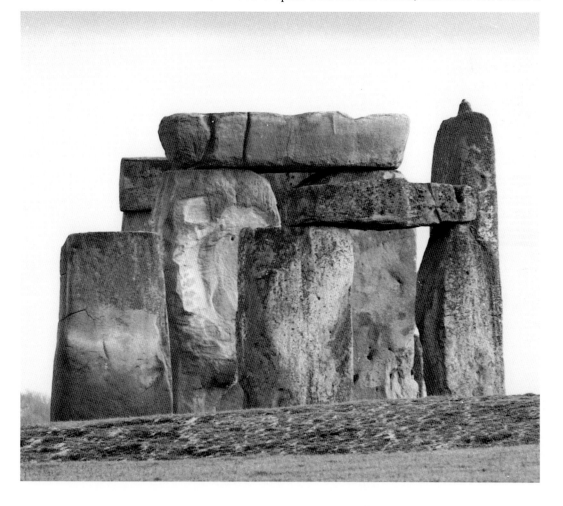

saw combinations of vertical and horizontal lines that made extraordinary compositions. I was sure that many who were familiar with the site would wonder how I had found so many strange images.

I've since returned to Stonehenge and been somewhat frustrated by the guardrails that prevent one from walking right up to the stones. Also because of a major increase in tourism to the area, there is now a store selling all sorts of memorabilia as well as a large parking lot to accommodate the bus loads of visitors who make this one of the highlights of their trip to Britain. All this commercializes the site somewhat disconcertingly, but I still enjoy the opportunity to explore the forms with my camera and take more and more shots to add to my experience of this infinitely fascinating creation.

The photographer John Pfahl had a similar experience some years ago with another famous site, Niagara Falls. His guide was a series of nineteenth-century etchings of the falls by a self-taught artist, Amos W. Sangster, who had portrayed this phenomenon of nature from almost every possible angle. Pfahl followed in Sangster's footsteps, exploring the nooks and crannies of the area and taking photographs in the same spots from which his artist-predecessor had made his drawings. The

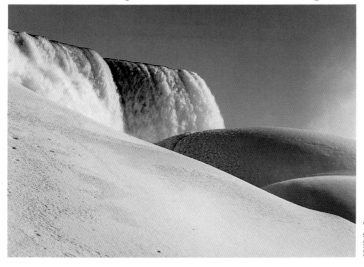

John Pfahl.
American Falls with
Snow and Ice Mounds.
Niagara Falls. 1985

David Leslie.
Susitna River.
Anchorage,
Alaska. 1992

result was a remarkable set of photographs in which the falls were revealed in their thunderous splendor. Pfahl's unique eye for form and color brought a new perspective to this well-known site. It also brought an immediacy to the viewer who could feel the presence of the falls even more directly than in Sangster's prints.

A friend of mine, David Leslie, recently sent me a set of photographs he had taken of a creek outside of Anchorage, Alaska, that drains into the Susitna River. He wrote me about the photographs:

> At this particular bend in the river, I could see the creek's source and its ultimate destination. It was also at this point that the water began to pick up momentum, as if it were suddenly impatient with its journey and anxious to move on quickly. At the same time, it moved from the relative security of rocks and creek bed to the open and uncertain expanse of the river. The scene reminded me of the life cycle. Water appeals to me because I view it as a cleanser of the environment. When I make an image of water, I am capturing a true moment in time that will never be repeated. I love its form, its texture and its power. It has a commanding nature that I respect and admire.

Some photographs have captured instants of historic importance and become icons of our time. We the viewers feel we are there with the photographer at that particular moment in time when something of great significance is taking place. The image becomes indelible when there is something about the photograph that we cannot forget once we have seen it.

One such icon was taken in World War II by the Pulitzer Prize–winning photographer Joe Rosenthal. On February 23, 1945, he photographed six U.S. Marines raising the flag on top of Mt. Suribachi of Iwo Jima, marking the end of what proved to be the bloodiest single battle of the Pacific war. He took many photographs at the scene; this one was what he called "right at the peak of the action." If it had been one tiny fraction of a second off he would have lost it. The angle of the flagpole, the flag blowing in the wind, the hands reaching up to grab the pole, the forward movement of the figures (particularly the one in front), the rubble on the ground—all create a sense of supreme tension at the climax of one of mankind's mightiest struggles.

There has been some controversy about this famous photograph, and Rosenthal was accused of having posed the Marines *after* the flag was in place. But in a careful review of what actually happened, Vicki Goldberg reported (in her excellent book, *The Power of Photography*) that a small flag had been raised earlier; Rosenthal photographed the Marines raising the official eight-by-four-foot flag that would be seen all over the island. Goldberg also pointed out that this may be the most widely reproduced and re-created photograph in history: 3,500,000 posters, 15,000 outdoor panels, and 175,000 car cards have been made from this image.

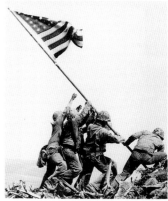

Joe Rosenthal. Iwo Jima. 1945

In a curious reversal of Pfahl's project to photograph what Sangster represented in his prints, a sculptor, Felix W. De Weldon, created the Marine Corps War Memorial in Arlington, Virginia, inspired by Rosenthal's photograph of Iwo Jima. The sculpture was installed nine years after the photograph was taken and has a more studied composition of the figures with idealized forms, including carefully composed hands around the flagpole. Even the flag was changed, presumably to give what the sculptor considered a better balance to the image. The one-hundred-ton bronze may well have succeeded as a monument because it reminded onlookers of the great photograph taken by Rosenthal, which captured a historic moment in a titanic battle.

Another unforgettable photographic icon is *Tomoko Uemura Bathed by her Mother* taken by W. Eugene Smith. This image breaks our hearts and wrenches our mind. It was published in the June 2, 1972, issue of *Life* and commemorated a terrible environmental and human disaster in Japan. It shows a horribly wasted figure of a young woman poisoned by mercury discharge from the Chisso chemical factory in Minamata, Japan. The mother, cradling her adult child, has a heartrending expression in her face, somehow punctuated by the white cloth wrapped around her head. The "crucified" daughter, in what seems like a modern-day *Pietà*, has a tortured unworldly look of impending death in her eyes. The stark black background contrasts with the dramatic highlights on the figures.

The whole scene is captured by a great photographer in a print that arouses in the viewer's mind a degree of horror that is virtually unparalleled in the history of photography.

Only a razor-sharp eye combined with a pounding heart could capture such a powerful image. It is perhaps the finest of its kind, but there are countless other images that have been taken by perceptive and caring photographers whose eye and heart were also moved by what they saw. Many such photographs have been published in books, magazines, and newspapers and exhibited in galleries and museums around the world. No doubt there are also vast numbers of fine photographs that have never been seen in public but can be found in archives of professional photographers or even mounted in scrapbooks or lying in drawers of nonprofessionals.

This indeterminate mass of photographs has become a central feature of our culture. Clearly we are living in an era that has been blessed with a new way of sensitizing the eye through the camera lens. Today more and more of us are learning how to preserve the images we see in the world around us by releasing the shutter in instants of potentially momentous discovery.

W. Eugene Smith.
Tomoko Uemura Bathed
by Her Mother.
Minamata, Japan. 1972

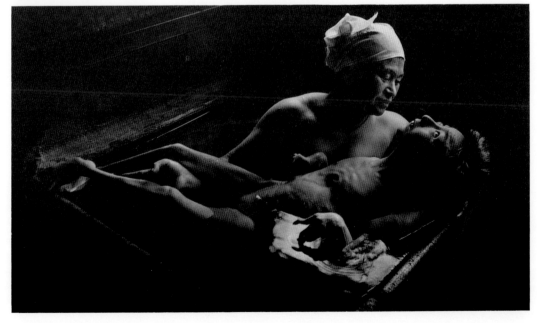

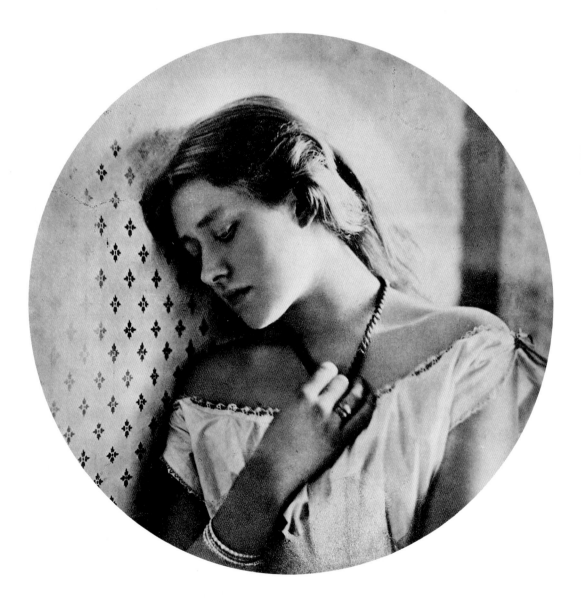

The Inner Spirit

Artists have been trying to represent the inner spirit of individuals in paintings and sculpture almost since the beginning of human life on earth. Achieving a likeness by reproducing an exact image of a person, even when artists were capable of doing so, has never been enough to fulfill this goal; what is sought is a posture or gesture or expression that conveys something of the character of the individual.

Perhaps the earliest known work of art, which in its own way is a masterpiece of figurative representation, is the *Venus* of Willendorf, from around 30,000–25,000 B.C. It is a generic portrait of "Woman" rather than a woman, with enormous breasts and an almost equally large belly and genitals but no face. In the Lascaux Caves, which are only half as old—dating from about 15,000 B.C.—there is a stick-figure painting of a man with an enormous, erect penis; this presumably is a portrait of "Man" rather than a man.

It was the ancient Egyptians who first began to portray individual men and women. Egyptian portraits of royal personages have a noble if not commanding bearing, with a vision of immortal life in their eyes as if eternity was their realm. The Greeks gave a heroic appearance to the mythical figures they portrayed in their monumental sculptures, while the Romans made even their most august emperors seem human. It was not until the fourteenth and fifteenth centuries that Western artists developed the idea of portraying what they considered to be the true character of their subjects, whether they were tragic biblical figures like Donatello's *Mary Magdalene* or sensitive and noble figures like Leonardo's *Mona Lisa* or homely but dignified figures like Piero della Francesca's portraits of the Count of Urbino and his wife. Other great masters—perhaps Rembrandt the greatest of all—followed in subsequent centuries to produce their portrayals of what they considered to be the inner spirit of their subjects.

Julia Margaret Cameron.
Ellen Terry at the
Age of Sixteen. 1864

When photography blossomed in the middle of the nineteenth century, one of its main contributions was thought to be a new and better method of creating portraits. The early photographers saw their technique as a successor to the art of painting, and their subjects were usually posed as they might have been before an artist's easel. Also, the technique of using glass negatives required individuals to maintain a position for as long as three or four minutes, making it impossible to take the kind of informal portrait we are used to today.

The character portrayed in nineteenth-century photographs, therefore, tended to be expressed in the way the photographer asked the subject to sit or stand. Some poses, particularly those of famous people, tended to be stiff and formal. But others were quite expressive, demonstrating the photographers' gift for probing the character of their subjects with imagination and sensitivity.

Among the most remarkable and moving of nineteenth-century portraits were by Julia Margaret Cameron. Always recognizable by their soft and touching quality, Cameron's portraits seem as if they were taken through a veil, eliminating distracting details and showing the essential parts of the person's face. Professional photographers of the time considered her an amateur because they thought her images were out of focus, but today we admire their integrity and simplicity. Although the subjects were posed, one has the feeling that one sees the individuals in an especially revealing light.

One of Cameron's loveliest portraits is of Ellen Terry at age sixteen (p. 50). It shows this beautiful young woman looking down pensively to her right, her simple dress dropped below her shoulders to reveal the gracious shape of her neck, her long hair flowing behind her, her hand fingering the necklace which forms a triangle below her chin. The lighting runs counter to common practice: instead of coming from her right to light up her features, it comes from her left, throwing her features into shadow and producing a highlight on the back of her neck and her left collarbone. The whole figure is in soft focus, with a pattern of wallpaper in sharper focus to her right where it provides

an accent to the image, and fading away in the rest of the photograph. The oval frame of the print helps to give it a cameo effect.

The lighting in Cameron's photograph of Virginia Woolf's mother, Mrs. Duckworth, is more direct, modeling the sensitive, deepset eyes—again looking down—highlighting the delicate nose, and bringing out the strong line of the turned neck. It portrays a gentle character in a moment of quiet contemplation. Her photograph of Sir John Herschel, the scientist whose theories played a significant role in the development of photography, shows him with a worried frown on his face, his white hair uncombed, a high-collared shirt bunched around his neck, his chin unshaven, his eyes staring at the camera.

The soft-focus technique found in Cameron's photographs became popular in the United States after the turn of the century, particularly with Edward Steichen and Clarence White. Gertrude Kasebier was perhaps less well known, but her portraits, particularly of American Indians, are especially touching.

This approach to portraiture had quite an influence on succeeding generations. I recently came across a series of four photographs taken in the early 1900s of a wealthy socialite turned actress, Elinor Patterson, who played the part of the nun, Megildis, in the Max Reinhardt–Morris Gest spectacle *The Miracle.* Apparently she was a great success; one critic wrote that she played the part "with a pervading haunting quality, eager with a spirit of unfulfilled youth." The sensitive photographs of her as a nun show her to be a beautiful young woman, emerging from the shadows that the unknown photographer used to great advantage, with a faraway look in her eyes that Margaret Cameron would have loved to have captured in one of her subjects.

I found the photographs in an estate sale at which I was also amused to discover a reprint of an advertisement by The Pond's Extract Company, featuring the "beautiful Elinor Patterson," describing the famous families of which she was a descendent and applauding her success as an actress. The point of the advertisement was to call attention to Patterson's "lovely skin with its

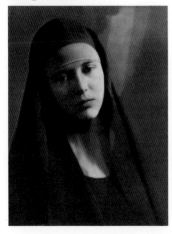

**Unknown.
Elinor Patterson
in "The Miracle."
Early 1900s**

rare petal texture, its flush of unfolding youth, its transparent delicacy, [which] in spite of the double strain put upon it [her social obligations as a member of Chicago's younger set and her acting career] must be kept in all its present perishable loveliness — imperishable!" Presumably the daily use of Pond's Two Creams had helped make her so beautiful in the photographs of her playing her part in *The Miracle.*

A major achievement in the art of the portrait was a series of photographs taken over a period of thirty years by Alfred Stieglitz of his wife, the painter Georgia O'Keeffe. One can't help feeling that these photographs, which began in 1917 when O'Keeffe was twenty-three years old, could only have been made by someone who had an intimate relationship with the subject. When some of the early portraits were first seen in public, several men asked Stieglitz if he would photograph their wives or girlfriends the way he photographed O'Keeffe. He was very amused. O'Keeffe said many years later that "if they had known what a close relationship he would have needed to have to photograph their wives or girlfriends the way he photographed me—I think they wouldn't have been interested."

Stieglitz photographed not only O'Keeffe's striking face but many other parts of her anatomy as well, and from many different angles—both with clothes and without. One of the best in the series shows only part of her face, with a wonderful composition of her delicate hands pressed together against her cheek, her fingers gracefully intertwined almost like her own paintings of flowers, clouds, and mountains.

In recalling her photographic sessions with Stieglitz, O'Keeffe once said:

> My hands had always been admired since I was a little girl—but I never thought much about it. He wanted head and hands and arms on a pillow—in many different positions. I was asked to move my hands in many different ways—also my head—and I had to turn this way and that. There were nudes that might have been of several different people—sitting—standing—even standing upon the radiator against the window—that was difficult—radiators don't intend you to stand on top of them. There were large heads—profiles and what not.*

Alfred Stieglitz.
Georgia O'Keeffe. 1918

* Georgia O'Keefe. *A Portrait by Alfred Stieglitz.* New York: Viking Press, 1978.

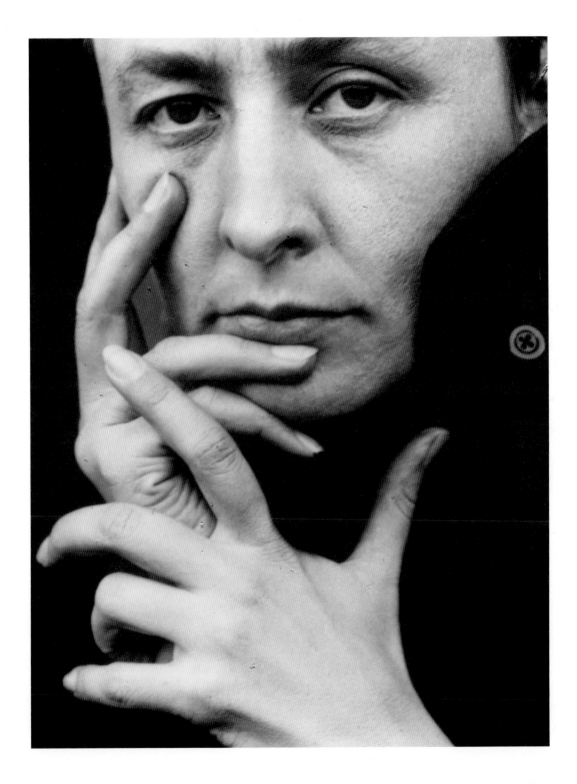

The photographs Stieglitz took of O'Keeffe constitute one of the most extraordinary achievements in the history of portrait photography. He captured her personality in a way that only a great photographer who was consumed with the beauty of the woman he loved could ever hope to achieve.

Portrait photography of public figures tends to be a challenge of a different order. Here the photographer has a limited time to get to know his or her subject and to get the person to behave in what appears to be a characteristic way. Philippe Halsman, who photographed more than one hundred por-

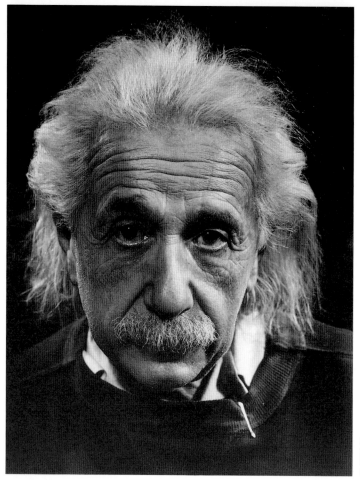

Philippe Halsman.
Einstein.
Princeton,
New Jersey. 1947

traits for *Life* magazine covers, was a master of this technique. He once told the story of how he made his famous photograph of the man he admired most in the world, Albert Einstein. Halsman respected Einstein not only because he was a scientific genius but also because he was a rare and wonderful human being. He had good reason to feel that way since Einstein had personally intervened on his behalf after the fall of France in World War II, and made it possible for him to escape from threatened Nazi captivity.

Einstein didn't like photographers (he called them "light monkeys"), but he acquiesced to his friend's request. And so one day Halsman set up his lights and began to take some pictures while the scientist sat at his desk doing mathematical calculations. Every photographer has a technique to warm up his subject and get them to relax. Margaret Bourke White used to start "shooting" her subjects without any film in the camera since she knew it would take time for them to relax. That was not Halsman's approach, but he, too, knew that the best shots would come later in the session. He described how the magic moment arrived while photographing Einstein:

> Suddenly, looking into my camera, he started talking . He spoke about his despair that his formula, $E=MC^2$, and his letter to President Roosevelt had made the atom bomb possible, that his scientific research had resulted in the death of so many human beings. "Have you read," he asked, "that powerful voices are demanding that a bomb be dropped on Russia now, before the Russians have the time to perfect their own?" With my entire being I felt how much this infinitely good and compassionate man was suffering from the knowledge that he had helped to put in the hands of politicians a monstrous weapon of devastation and death.
>
> He grew silent. His eyes had a look of immense sadness. There was a question and a reproach in them. The spell of this moment almost paralyzed me. Then, with an effort, I released the shutter of my camera. Einstein looked up, and I asked him. "So you don't believe that there can ever be peace?" "No," he answered. "As long as there will be man there will be wars." *

Afterward, when Halsman showed the photograph he had taken to Einstein's daughter, Margot, tears came to her eyes. "I cannot tell you how much this portrait moves me," she said. Ein-

* Quoted in Philippe Halsman. *Portraits*. New York: McGraw Hill, 1983.

stein was more detached. "I dislike every photograph taken of me," he said. "However, this one I dislike a little bit less."

There probably was no one more humble about his accomplishments than Einstein. Once, when receiving the "One World Award" at a ceremony in Carnegie Hall, he said "In the course of my long life I have received from my fellow-men far more recognition than I deserve, and I confess that my sense of shame has always outweighed my pleasure." This award was more painful than any of the others, he said, because he had become aware of how little chance there was for reason and justice to prevail in the search for peace.

Although Einstein disliked having photographs taken of himself, he had one of the most photogenic faces of his time. In Halsman's portrait of him, his unique character was somehow evident in the expression on his face, his bushy mustache, the unkempt look of his hair. One senses not only his intelligence but his sensitivity and extraordinary modesty. There is something in Halsman's photograph that is reminiscent of Rembrandt's late self-portraits—a picture of the very soul of a great and humble man. We could be imagining it, but when we look into Einstein's soft and watery eyes we feel we are in the presence of someone who has seen into the farthest reaches of the universe and has gained some special insight into the ultimate meaning of human existence.

Unlike Einstein, most celebrities enjoy being in the limelight and having their picture taken by a prominent photographer. And the one photographer who has been most in demand by celebrities for more than half a century is Yousuf Karsh. He has a unique gift of making portraits that become almost as famous as the person being photographed.

Karsh's talent is not only to portray an individual's facial features in a compelling way but to express the subject's personality in the very composition of the photograph. Indeed one of his most striking portraits is of the cellist Pablo Casals playing his immortal Bach, photographed from the back. Karsh said later that while listening to Casals play he sometimes forgot to click

Yousuf Karsh.
Pablo Casals.
Puerto Rico. 1954

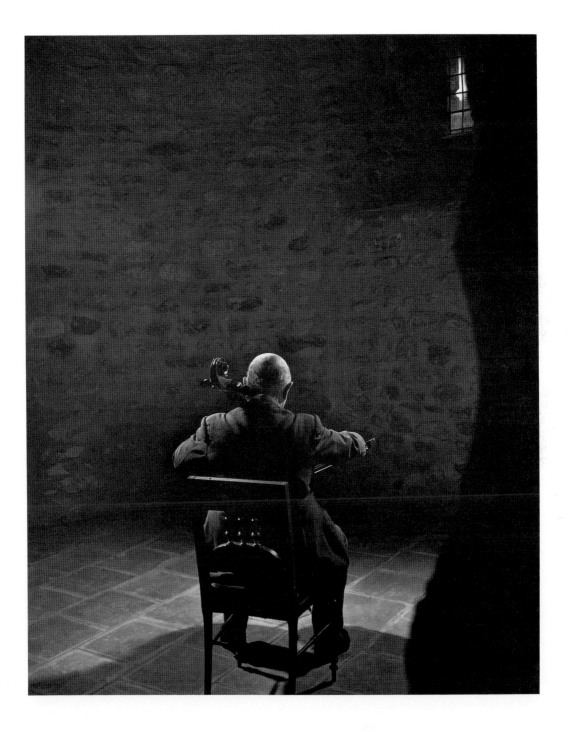

the shutter because the music was so overwhelmingly beautiful. Although nothing can be seen of Casals's face, one feels the intensity of his concentration and the quality of his personality in the shape of his body, the loving way he holds his instrument. Even the simple stone floor beneath him and the textured wall in front of him tell something about the personality of the man. After his ninety-third birthday Casals wrote, "If you continue to work and to absorb the beauty of the world about you, you find that age does not necessarily mean getting old. . . . I feel many things more intensely than ever before, and for me life grows more fascinating. . . . My work is my life. I cannot think of one without the other. Each day I am reborn. Each day I must begin again. . . . Every second will never be again. . . . I think I would continue [to play and practice] if I lived for another hundred years. I could not betray my old friend, the cello."

A legend himself in the world of photography, Karsh has probably photographed more living legends of his time than anyone else in history, and he has stories to tell about each of the people he has photographed. One of his more touching accounts has to do with a photograph he took of Ernest Hemingway in Cuba. Hemingway had been in a terrible air crash in Africa which had left him injured both physically and psychologically. Although it was not generally known, Hemingway had suffered severe bouts of depression both before and after the accident and had come to think of himself as a failure. Somehow Karsh's sensitive and genial manner seemed to restore Hemingway's self-esteem during the photo session and what became the most famous portrait of the Nobel Prize–winning author showed the old Hemingway looking as confident and determined as ever. Two weeks before Hemingway committed suicide, his wife Mary telephoned Karsh to say that his portrait was the writer's favorite, and urged him to release it to the press as often as possible. In retrospect Hemingway's wife seemed to be calling for this photograph to be the image of her husband she wanted to be preserved for posterity—an image of nobility and courage in the face of adversity, of a man saying to the

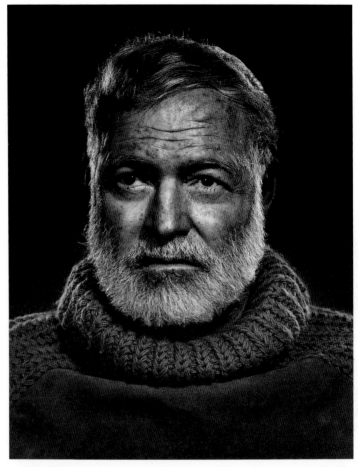

world, "Here I am, this is what I am, this is the way you should remember me."

As we look at the photograph today we see Hemingway's intelligent, creative eyes looking off to his right, peering into the distance. There is something vulnerable in the look of his eyes, which Karsh says he felt at the time. His lips are firm and sure, but slightly turned down, signifying determination more than exhilaration. His hair lies neatly on his head, not brushed carefully but not wild, and his trimmed beard, beautifully defined by the careful lighting, shows him to be aware of the handsome and striking appearance that was part of his public persona. His high-

necked, leather-fronted sweater designed for him personally by Christian Dior adds to the quality of strength and determination with which a man who has lived dangerously prepares to face whatever lies ahead.

Helen Marcus recalls with great feeling the time she photographed the Nobel– and Pulitzer Prize–winning author, Toni Morrison, for the advertising and promotion of her book, *The Song of Solomon*. Marcus has a long record of producing fine photographs of many distinguished individuals, particularly artists and authors. She was especially excited about the opportunity to photograph Morrison, whose previous books had moved her deeply. On this particular occasion, in 1978, Morrison came to Marcus's studio to be photographed, and the author talked a good deal about her personal life—the two sons she was raising without a father, her work as an editor at Random House and, of course, her writing. They also talked about black/white race relations at the time, and what was happening in America that was both troublesome and hopeful. The rapport the two developed with each other enabled Marcus to take a photograph that was especially successful in revealing the author's character — her seriousness, her sensitivity, her humanity. Afterward, Toni Morrison said it was one of her favorite portrait shots, and in 1993 it was chosen as the image for a Swedish postage stamp honoring her as the Nobel Prize winner for Literature.

Helen Marcus.
Toni Morrison.
New York. 1978

It is possible, although obviously not desirable, for a professional photographer to make an impressive portrait without knowing anything about the person. I once saw Arnold Newman, one of the finest portrait photographers of our time, tackle an impossible task with an impatient businessman who needed a good photograph of himself but didn't want to spend the time to have it done properly. Newman, being a good sport and willing to take on the assignment, went over to the businessman's brownstone house before his subject arrived and set up his lights in an appropriate area. When the businessman showed up and condescended to give the photographer a few minutes of his valuable time, Newman managed to take a series of shots. It was a whirlwind experience, and when the job was completed, it was

clear that the man's face had been photographed with great skill, but it was also clear that he could have been a man from outer space—or a bowl of fruit. No photographer could have expressed the true character of a subject in that hasty manner.

It is difficult to explain how a genuine knowledge of a person is translated from a photographer's mind into the camera and on to the film. It somehow has to do with the way the subject relates to the photographer while the photographs are being

David Finn.
Raleigh Warner.
New York. 1985

taken. If the subject is relaxing with someone who is a friend, not being self-conscious, not trying to "look good" or assuming an unnatural expression; and if the photographer has an eye out for those special moments when a characteristic or revealing expression or gesture takes place, a mental signal causes the photographer's finger to press the button at precisely the right instant.

If one has never met the subject before, which is often the case when taking a portrait shot of a prominent person, some kind of chemistry needs to be established between the photographer and the subject if the result is to be more than routine. I once wrote a series of articles called "The CEO as a Whole Man" on the chief executive officers of some of the largest companies in the world. My purpose was to find out what kind of people ran these companies, what their interests and personal lives were like, what they were most proud of in their lives, what they most regretted. I took their photograph after I interviewed them, and almost always the conversation we had had about their personal interests helped prepared the background for their portrait. The last thing I wanted was the kind of "mug shot" so often found in annual reports—well-groomed executives smiling about their self-proclaimed successes.

I particularly remember the photograph I took of Raleigh Warner, the chief executive officer of Mobil (p. 63). We had talked about his personal role in Mobil's involvement in public television, op-ed advertisements, and design and arts programs. On a hunch I asked him where in the office he especially liked to work, sit, talk to others, and think. To my delight he walked over to a window, pulled aside the curtains and sat on the windowsill looking out at the city below. That was where he did some of his best thinking, he said. And that was the way I photographed him, sitting on the windowsill and looking pensively into the distance, with his face reflected faintly in the glass. Some time later I was delighted to find that not only was my photograph of him published in the magazine I was writing for, it was also featured on the cover of Mobil's own magazine in an issue published at the time of Warner's retirement and highlighting his accomplishments.

David Finn.
Isamu Noguchi.
New York. 1985

I have taken other portrait shots of well-known figures and always tried to get them to show some personal or private part of themselves. I once spent an afternoon with the sculptor Isamu Noguchi after photographing a number of his works. As he showed me around his garden, he pointed to one stone that was lying on the ground. Suddenly he dropped on his knees and put his arms around the stone and told me how much he loved it the

way it was. He said he had not carved the stone at all; he had simply broken it into parts so that one could feel the quality of its inner as well as outer reality. That broken stone was his sculpture. I photographed him while he was on the ground talking to me with his arms around the stone.

I had a similar experience with Isaac Bashevis Singer. The writer Alfred Kazin and I visited him in his New York apartment, and we talked about his books and stories. During the course of our conversation, he took us into what he called his "Garbage Room," which he said was the one room in the apartment in which his wife

David Finn.
Isaac Bashevis Singer.
New York. 1985

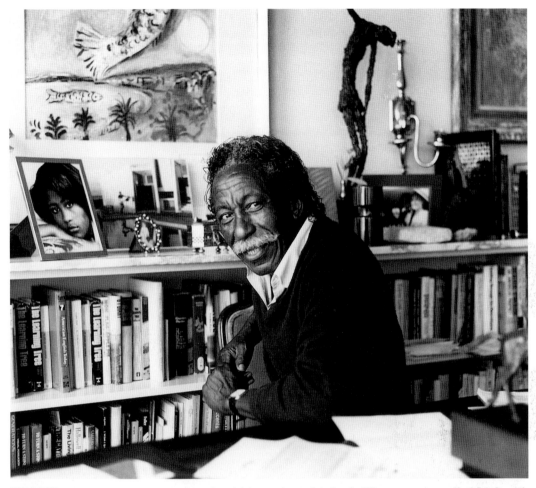

David Finn.
Gordon Parks.
New York. 1985

permitted him to keep his junk. The room was piled high with books, old newspapers, and magazines, and on the wall, hung askew, were framed awards he had received over the years. One of them, hanging modestly with all the rest, was his Nobel Prize. He thought the room was a joke, but he loved showing it to friends, and I photographed him standing in the middle of the chaos.

Still another portrait I enjoyed taking was of Gordon Parks. Photographing a famous photographer can be daunting, but Parks was kind and considerate and cooperative, and it turned out to be a delightful experience. He has such an outstanding

reputation and such a strong face that he has been photographed by many other photographers. I was pleased that I had caught Parks sitting at his desk in a natural pose, with some of his favorite pictures on the wall behind him. I saw him several times after I took that photograph, and I felt increasingly that I had been able to reveal something of his sensitivity and gentleness, as well as his remarkable creativity.

The more intimately one knows the person being photographed the more likely one is to get a shot that captures the inner spirit. That became clear to me when I photographed the theologian Louis Finkelstein, with whom I had a lifelong relationship. For Louis Finkelstein, the one-time chancellor of the Jewish Theological Seminary in New York, whose pioneering ecumenism had made him a world-renowned religious figure and the subject of a cover story in Time magazine, was my uncle. I had worked with him for years on many of his visionary projects, including the Institute of Religious and Social Studies—the only school in the world in which ministers, priests, and rabbis could study together.

One of my most vivid memories of Louis was on a weekend when he invited Chief Justice Earl Warren to visit the seminary to learn something about the wisdom of the Talmud. On Sunday morning a large group of scholars and laymen associated with the seminary gathered to meet the chief justice. Louis gave a speech to the large crowd in Warren's presence, and I remember his saying in a sort of self-deprecatory way that people accused him of having a messianic complex. He knew that this was a common criticism of his ambitious plans. But then he raised his arms like a biblical prophet, and with a trembling voice shouted: "It's true! I want to make the world a better place!" The room seemed to shake as he spoke, and the people in the audience were transfixed. I felt at that moment that they would have followed him to the ends of the earth.

Years later I asked Louis if I could take his picture for a book I was working on, and he assented. Although he had something of Einstein's humility about him and paid little attention to worldly

David Finn.
Louis Finkelstein.
New York. 1985

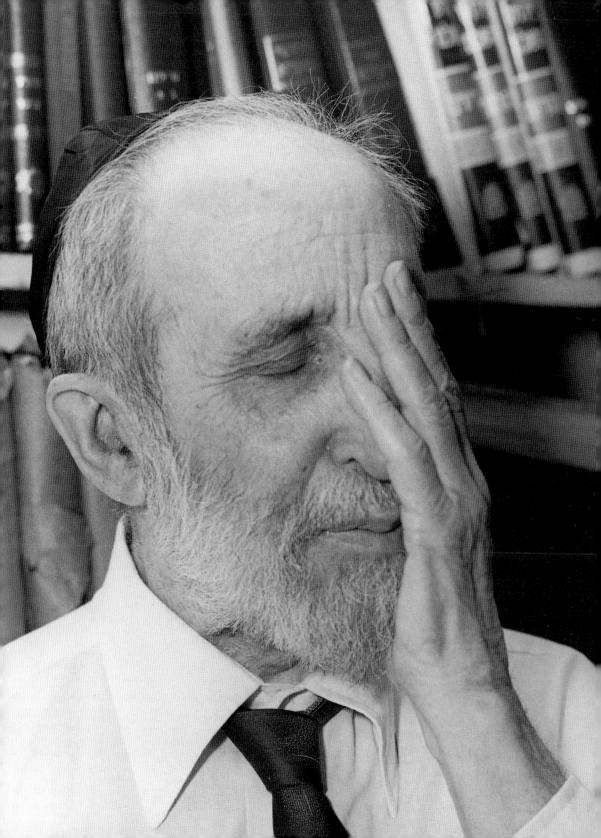

matters—he lived in an apartment with paint peeling from the walls and ceiling and books piled up everywhere—he felt that if it would please me to take his picture, it was all right with him. I took roll after roll of photographs of him as we sat talking in his modest apartment. To make it as informal as possible, I had not brought lights with me, relying instead on whatever light was available. Later, when I looked at all my negatives and contact prints, I discovered one shot that was perfect. Louis had been talking about the ethical problems of our time, one of his recurring concerns. He put his hand to his face in a moment of profound reflection. His long, delicate fingers reached over his closed eye to his furrowed brow in a gesture reminiscent of Rembrandt's portrait of Jeremiah in *Jeremiah Lamenting the Destruction of Jerusalem.*

I knew that this was not an expression of despair, but rather of faith. He grieved for the troubles of mankind and was pained that it had not been given to him to realize the great dreams he had to provide succor. But he never complained. He took the world as a sacred gift and considered life and prayer and observance as a great blessing. In the last decade of his life he had worked on a series of four volumes interpreting an ancient text, which a scholar had said that a hundred years from now would be considered more important than the discovery of the Dead Sea Scrolls. He dismissed the compliment as a gross exaggeration but was grateful that he had been able to complete the project in his lifetime.

Shortly before he died at the age of ninety-six he told me he was thinking of starting to work on another book. He had several ideas he was toying with; one of them would be a projection of what life would be like a million years from now! "A million years from now," he said, "man will know God!" It is incredible to think, he said with great excitement in his voice, what that will mean to the nature of human existence. I urged him to write that book; he must be the only one in the world who could even think about looking ahead a million years. And his vision of that far distant future could be a great gift to mankind, particularly at that moment in time when we were facing the future with such apprehension.

Unfortunately he never did get a chance to write even a page of that new book. But I like to believe that this was the kind of thinking that was going on in his mind when I took my favorite photograph of him in deep thought with his hand held to his face.

An entirely different personal outlook was evident in the many photographs I took of the sculptor Henry Moore. He, too, was a dear friend for many years, and I knew him to be a very humble person, conscious of his own place in history but with no sense of hubris. I once heard the art historian Herbert Read say that the four great sculptors in the history of Western civilization were Phidias, Michelangelo, Rodin, and Henry Moore; when I repeated that to Moore, he laughed and said it was "silly." His wife, Irina, considered it her responsibility to make sure his fame didn't go to his head and to keep him from being overly impressed by the many honors heaped on him. She went about her daily gardening chores around their sixteenth-century farmhouse in Much Hadham, England, while he went to his studio to work on sculptures or drawings. As far as both of them were concerned her work was as important as his.

When my wife and I visited them for tea, which we did two or three times a year, we found them always to be warm and friendly and open. After tea one of our regular rituals was for me to take a photograph of him. It was something that seemed quite natural to a person who was constantly the subject of books, magazine articles, television programs. He never posed, he just went on talking or doing his work. I used to marvel at how this man, who in every other respect seemed to be an ordinary human being, had fingers and a mind that could produce such extraordinary works of art.

Every time we came back to Much Hadham I would bring prints of photographs I had taken on our last visit, and Moore always seemed pleased. My favorite photograph of him was not taken in Much Hadham, however, but in Florence, Italy, where Moore's work was exhibited in a place he loved dearly, Fort Belvedere, on a hillside overlooking the city. Moore considered

the exhibition of his sculpture in the open spaces of Fort
Belvedere to be a high point in his life. It would enable him to
see how his sculptural forms would stand up against the great
Brunelleschi dome of the cathedral and the other architectural
masterpieces of the Renaissance that he admired so greatly.

The exhibition opened to great acclaim and met, if not
exceeded, Moore's fondest hopes. My wife and I could not be
there for the opening, but we visited Florence toward the end of
the exhibition on a day when his friends the architects I. M. Pei
and Gordon Bunschaft were there as well. We all climbed the
steep hill to the top of Fort Belvedere with Moore, and it was

clear that this was a special moment for him. Two of the greatest architects of our time were seeing his sculpture in this magnificent setting, and I was there to witness their enthusiastic reaction. Naturally my camera was clicking away as we moved around the exhibition, and at one moment I caught Moore looking upward into the sky, with a studied look on his face and the graceful sweep of one of his tall sculptures forming a wonderful counterpoint to the shape of his features, the creases in his neck as his head turned, even the lines of his thick hair flowing in the back of his head. It all happened quite by accident, although if I hadn't had my camera cocked for such fortuitous opportunities I would never have gotten that shot. It seemed to me that I had just managed to catch the sculpture at an angle that made its forms seem an extension of his face, and the combination created a unique portrait of a great sculptor.

One of the most touching portraits I ever took was of a twenty-seven-year-old woman, Elizabeth Noble. I had known Liz since she was a young teenager, the only child of a dear friend of the family, Lorna Noble. When Liz was fifteen, she contracted glandular fever, the result of which was acute renal failure. Both of her kidneys were destroyed. Although she was very close to her mother, who lived and worked in London, she was an independent and self-reliant young woman, and when she was twenty-two she moved into a tiny apartment in St. Albans, about forty minutes away from London. Although she required regular dialysis treatment, she never lost her good nature. Her constant closeness to death, which she accepted with such remarkable grace, combined with her natural youthful exuberance, created a very special aura around her and she was beloved by all who knew her. Two kidney transplants were made, and both failed, but this did not dampen her spirits.

On one of our trips to England, I offered to take a series of photographs of her. I thought there was something radiantly beautiful about her face that I could capture on film. It was my way of showing Liz—and her mother—how much I loved her. When I returned home and made some prints, I felt I had suc-

**David Finn.
Elizabeth Noble.
London. 1989**

ceeded in capturing her remarkable character, and I know both Liz and Lorna liked the prints I sent them. I was particularly pleased with one shot that showed her lovely smile, with highlights on her features that somehow conveyed the magnetism we felt about her.

A year later, Lorna telephoned with the news that Liz had suddenly become terribly ill and died. Although we had all known that she was not expected to live very long, it was heartbreaking to know that the end had come.

We all have snapshots of dear ones who have died, and looking at them from time to time brings back warm memories. Recently I did some photographing at a cemetery in Siena, Italy, for a book on nineteenth-century sculpture in Siena. There are scores of private chapels in the cemetery and many of them have major sculptures created by leading artists. On the way to the chapels I passed long corridors lined from top to bottom with slabs for people buried there, and each one had a photograph of the loved one who had died. One can imagine how much care was taken by the family to select a photograph that showed the individual as the family wanted to remember him or her.

My photograph of Liz is not a funerary picture. It is a joyful photograph which reminds me of a very beautiful girl at a very tender moment. I'm glad to have taken that photograph as a way of perpetuating her rare and precious spirit.

The art of seeing reveals something about the character behind the face, that makes the face what it is, or that can be read when looking at a face with a probing eye. The purpose of a portrait can be to ennoble the subject, as is the case with many monuments and official portraits. But the portrait photographs that deserve a place in the history of the art of photography reveal the inner spirit of the subject rather than merely extol their heroic achievements.

When W. H. Auden was in his later years the most visible characteristic of his facial appearance was the multitude of wrinkles that creased his face. A friendly woman asked him one day why

he didn't arrange for a surgeon to remove his wrinkles. "Madam," he is said to have replied, "it has taken me a lifetime to develop them; I wouldn't think of taking them away!" Perhaps more than any other art form, photographs tell the truth about their subjects, and the photographers who know how to find that magic moment when the inner spirit of an individual is revealed through a facial expression, a gesture, or a particular stance are artists who have developed a special insight into the deeper realities of the human character.

**Yousuf Karsh.
W. H. Auden. 1972**

The Outer Visage

Not all portraits are intended to reveal the subject's character. Some portraits portray the outer visage of individuals whose appearance somehow strikes a chord within the photographer. It may be because the photographer sees individuals who appear to be particularly beautiful or particularly amusing, or perhaps they represent a particularly poignant or significant aspect of life. Usually these turn out to be shots in which a photographer can make a personal statement about the ways of the world.

We all can be lookers at people in the course of our every day lives. Some individuals have faces that can touch the soul, and I confess that there are some I can't take my eyes off when I pass them by. This can happen when walking on a city street or country road anywhere in the world. Often I find myself staring unashamedly at a lovely young woman who is worthy of a painting by Raphael.

Actually all of us have our own inner sense of ideal beauty and we especially enjoy the images by those great artists that coincide with the kind of vision that makes our hearts beat faster. If we

F. Holland Day. Tow-headed Girl in Chiton. c. 1897

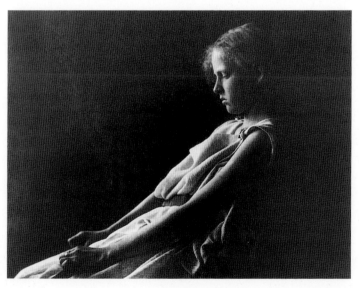

David Finn. Washington Square. New York. 1982

keep our eyes alert we can be at least equally excited when we discover manifestations of such an ideal in the flesh. In a way we are revealing as much about ourselves when we respond to such a vision as about the person inspiring us. And that is true of photographers as well; their ideal of beauty shows us something of their own inner feelings.

When we look at a photograph by F. Holland Day called *Tow-headed Girl in Chiton*, we see a very serious, beautiful young girl holding her dress rather delicately with outstretched arms, the light falling sharply on the edge of her figure and throwing the rest of the photograph into darkness. We have no idea who the girl is, but we have the feeling that the photographer happened to catch his subject at just the right moment. He may or may not have known her, but he clearly liked what he saw and gave us a vision of sheer loveliness.

Paul Edwards.
Joanne Baskerville.
New York. 1992

At the other end of the spectrum are photographs of men and women who pose as models. We may pay little attention to these as photographs, since we are meant to think of the person more as an impersonal attraction for the objects being displayed than as an individual. Yet the photographs are often a product of skillful posing and lighting, as can be seen in the portrait of Joanne Baskerville taken by Paul Edwards. In this case, I know the subject rather than the photographer; besides being a model, Joanne is an executive in the accounting department of Ruder·Finn, and I found this particular photograph to be a lovely portrayal of her charm and intelligence as well as her beauty.

Frederic Brenner.
Château Raba.
Bordeaux. 1991

Sometimes photographing individuals has as much to do with what they represent symbolically as what they look like. That was a factor in the remarkable odyssey of Frederic Brenner, who devoted some fifteen years of his life to photographing the Jews of the world. A brilliant young man, with a Ph.D. in social anthropology from the Sorbonne and winner of the Prix de Rome, Brenner traveled all over the world for his unique project. He called it "Chronicle of Exile: A Vision of Memory," and it included photographs taken in the remote regions of the former Soviet Union, Africa, India, all over Europe, the Middle East, and

the United States. Elie Wiesel wrote that Frederic Brenner's project was "not simply necessary but urgent, one that will render memory a service by integrating it into history." He added that "for a Jew, memory is his most precious possession, without which he would not be a part of our people." Wiesel believed that Brenner's photographs helped "to open the doors of our collective memory" and that he would succeed in his task because he had "the gift of seeing."

One of Brenner's most memorable photographs is of the Château Raba, in Bordeaux. The Raba family that lives in the service lodge of the baronial castle today is no longer Jewish, but they are descendants of the "Nacion" or Portuguese nation, the term used for Portuguese Jews who settled in the cities of Western Europe after the Inquisition spread to Portugal in 1536. The original Rabas, whose portraits their descendants proudly hold, were silk merchants in Braganca. Like other Sephardic families, they became very influential over the years, so much so that even Napoleon Bonaparte's wife, Josephine, was their guest when she visited Bordeaux in 1802. Brenner's haunting photograph underscores the pride of heritage still existing today for the Raba family: the portraits provide historic

faces for the contemporary family members, who are holding up the paintings.

When working on a book about New York I found myself walking around Battery Park City with my camera on a late afternoon. Suddenly I caught sight of a loving young couple standing alone against a parapet, looking soulfully into each other's eyes. Her hand was resting on his chest as she leaned forward, pressing her body against his, her loose or open blouse slipping seductively off her shoulders, while he stood with his elbow on the wall, welcoming her advance. Using a long lens, I managed to photograph them with the New Jersey shore faintly seen in the distance and a high-rise building over his head. It was a shot that never could have been posed and which I thought had a magical quality about it.

David Finn.
Washington Square.
New York. 1982

Human interest photographs of people one comes across are entirely different. Once I walked around New York's Washington Square, where New York University students hang out in between classes, and I pointed the long lens of my camera at different groups of people. Suddenly I saw a scantily clad man looking very strange with a black cloth over his head, one hand putting a popsicle in his mouth and the other holding his crotch. I didn't realize just how funny the scene was until I printed the photograph and saw another man standing nearby looking with amused disbelief at what was passing by (p. 76).

There are tragic figures that break the heart. Among the most tragic I have photographed was a bag lady sitting on a low wall on a city street. She was a scrawny woman who appeared to be just skin and bones, with a sacklike dress hanging on her emaciated body, her jaw jutting out, her mouth partly open as if about to growl like an angry animal. I couldn't help thinking of Goya's *Disasters of War* etchings, which depicted the horrors of human degradation and suffering. This woman was a victim of our urban wars and was a witness to the shame of our cities.

One of the most famous photographs of human poverty was taken by Dorothea Lange. It shows the figure of an apparently homeless mother dressed in rags, just visible in the shadows, with

David Finn.
Disasters of the City.
New York. 1982

Dorothea Lange.
Migrant Mother.
Nipona, California. 1936

a child huddled on each shoulder as if seeking protection from the hostile world, an unwashed baby wrapped in an old blanket on her lap. Her hand is raised to her chin as if she is wondering how she can go on, and the pained expression in her face reflects what appears to be total despair.

Another unforgettable photograph comes to mind, this time not of a destitute person but of a man at work in what seems to be inhuman conditions. The photograph by Lewis Hine suggests the repetitious motion that can drive someone out of his mind and was so brilliantly satirized in Charlie Chaplin's film Modern Times.

Equally moving and dramatically composed is a photograph by Cornell Capa of a political prisoner in Paraguay (p. 84). The face

of the prisoner, partially seen through a small opening, stares out at the cell bars that separate him from the world outside. We can see the daylight through an arch at the end of a corridor, but we realize that the prisoner cannot see it. The angles of the bars counterbalanced by the angle of the concrete enclosure that is the cell dramatize the isolation of the prisoner.

One's heartstrings can be touched by all these photographs — beautiful people captured by photographers who appreciate their loveliness; strange people in surprising poses that reveal

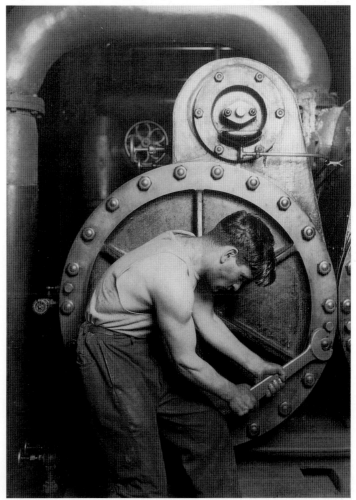

**Lewis Hine.
Steamfitter. 1921**

some characteristic of contemporary life; tragic people who elicit our profound sympathies.

As I walk the streets of any city, or stand still on a corner and watch the people pass by, I find that I am endlessly fascinated by what I see. Each individual is different. Some are homely, some are beautiful, some are undistinguished. There are young and old and middle-aged, men, women, and children, talking, laughing, arguing . . . angry, happy, thoughtful . . . sexy, fashionable, odd . . . hurrying, strolling, dawdling . . . confident, confused, upset.

One day while waiting on a busy street for my wife, who was shopping in a supermarket, I saw a group of boys unloading a truckload of cartons of soft drinks; the boxes were stacked high on the truck, and the process would clearly take an hour or more. One boy stood on the truck and tossed a carton to a second boy who stood on the street; he threw it across the sidewalk to a third boy, who threw it to a fourth piling the cartons in front of the store. There was a constant flow of people on the street as this was taking place, and the throw across the sidewalk had to be made in between individuals or groups walking along. Each of them stopped for a second or two to avoid being hit by a flying carton, and it almost seemed to me as if they were posing for me to take their photograph. It was an amazing experience and I was dazzled by what I saw—the contrasts, the variety, the endless flow, this parade of humanity.

My wife took much longer than she expected, but I didn't mind the wait; I could have stayed there all afternoon. I imagined that I was invisible, standing there with my long lens shooting the passersby as they came up to the flying cartons and producing an encyclopedia of human experience. It was a fantasy, of course, but it enabled me to experience the momentary vision of a multitude of individuals walking in the street, each face revealing for an instant a world of its own.

Revelations

One bright summer afternoon, schoolteacher Aaron Siskind was strolling along the waterfront of Gloucester, Massachusetts. Suddenly a glove, lying on the wharf, caught his eye. In a moment of inspiration he saw in his mind's eye an image of the glove as if it were standing up vertically. He looked at it through the inexpensive camera he was carrying and was astonished to find something very striking rather than a forlorn object lying on the ground. He snapped the shutter, and when the film was developed he realized he had created a photograph of rare and surprising beauty. Siskind went on to become one of the leading photographers of our time, finding revelations in all kinds of subjects that others never bother to look at — globs of tar on the road, oil stains on paper, stones in a fence, paint peeling on a wall. When I spoke to Siskind shortly before his death, he verified the truth of the "glove" story, but to my disappointment, I have never seen the famous photo!

There is something breathtaking about the forms that a perceptive artist can find in hidden views of the world around us — hidden because nobody bothers to look at them. I once was walking up a stairway of the List Building at Brown University with Henry Moore, when suddenly he stopped and stared at a spot on one of the steps. "Look how beautiful that is," he said incredulously. I looked, and saw the wonderful shape and subtle colors in what must have been a stain that cleaning fluids couldn't remove. On another occasion, while sitting with him in his studio, watching him work on a watercolor, he suddenly picked up a rag he had been using to dry his brushes, and with a chuckle said, "That's as good as any of my drawings!"

Natural phenomena that come into being free of any human intervention have a different quality from anything that might be created by an artist. A perceptive viewer may admire them, but the photographer records these remarkable sights and dazzles others with his revelations. The very idea that these mysteri-

**Paul Strand.
Abstraction,
Porch Shadows,
Twin Lakes,
Connecticut. 1916**

ous forms exist in reality stretches the mind. They even suggest a reality beyond the one we know.

As I have become conscious of the beauty of these random shapes, created neither by nature nor by a human hand but rather by a strange interaction between the two, I find myself wandering around with my camera at odd moments hunting for things to shoot with my camera. Sometimes I am struck by curious examples of graffiti that when framed in my lens create intriguing compositions, or an unusual mark on the side of an old wooden lamppost that looks especially striking, or the shape of an iron grating against the sky. One of the most intriguing photographs I've taken of random forms was of a woman with a multicolored dress walking by a wooden structure in front of a building site where a miscellany of torn posters and graffiti had created a work of art worthy of a Robert Rauschenberg or Jasper Johns. The whole scene was a pure accident, but somehow it came together as a statement about life in our times that I found compelling (p. 90).

The experience of coming across these revelations is reminiscent of a passage in W. B. Yeats's poem "Byzantium." Yeats was trying to affirm the existence of some ultimate reality beyond the noblest creation of nature or mankind.

David Finn. Iron Railing. Rio de Janeiro. 1992

> Miracle, bird or golden handiwork,
> More miracle than bird or handiwork,
> Planted on the star-lit golden bough,
> Can like the cocks of Hades crow,
> Or, by the moon embittered, scorn aloud
> In glory of changeless metal
> Common bird or petal
> And all complexities of mire or blood.

The random photographs of the desiderata of our society can hardly be described as golden handiwork, but in their own way they are miracles of beauty as spellbinding as anything created purposely by human hands.

Consider the comments Edward Weston wrote in his *Daybooks* about his experience in photographing different objects—shells, squash, and above all peppers. He photographed peppers again

Aaron Siskind. Scrambled Fence. Harlan, Kentucky. 1951

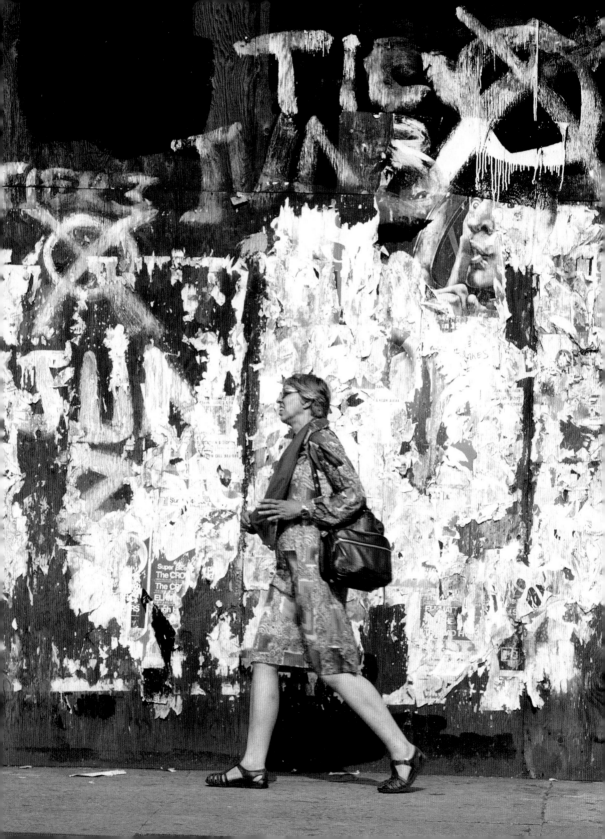

Right: Edward Weston.
Pepper No. 30.
Carmel, California. 1930

Opposite: David Finn.
Union Square.
New York. 1982

David Finn. **Eggplant.**
Sharon, Connecticut. 1991

and again over a period of many years, at different times of the day, in different lights, working sometimes for hours to get the view he wanted. Then on August 2, 1930, a miracle occurred:

> . . . just as the light was failing, [a photograph] quickly made, but with a week's previous effort back of my immediate, unhesitating decision. A week?—yes, on this certain pepper, but twenty years of effort . . . have gone into the making of this pepper, which I consider a peak of achievement. . . . It is a classic, completely satisfying—a pepper—but more than a pepper: abstract, in that it is completely outside subject matter. It has no psychological attributes, no human emotions are aroused: this new pepper takes one beyond the world we know in the conscious mind . . . into an inner reality—the absolute—with a clear understanding, a mystic revealment . . . through one's intuitive self, seeing "through one's eyes, not with them"; the visionary.*

91

*Quoted in Nancy Newhall, ed. *Edward Weston, The Flame of Recognition*. New York: Aperture, 1975.

Recently I was asked if I would take a series of photographs of eggplants for a somewhat exotic book which would have a text on the eggplant's history as well as eggplant recipes from different countries. I remembered Weston's photographs of peppers and wondered if I would have the same reaction to the forms of eggplants. As it turned out what intrigued me more than the form was the color of the fruits and the richness of their texture — both when they were on the plant and when I placed them against a colored background as I would a work of sculpture (p. 91). The results were quite striking, although I know that I didn't come close to the revelations of archetypal forms found in Weston's masterpieces.

Harry Callahan was a visionary much like Weston, and like Weston he found his miracles in commonplace objects. His achievements have earned him the description of "photographer of the obscure and the insignificant." Paul Strand also recognized that the commonplace can be beautiful, even when it has to do with shadows falling on a flat surface. In a photograph taken in Twin Lakes, Connecticut (p. 86), there is no way of knowing what the subject is and where the shadows come from. But it doesn't matter. We know that there was something *there* for the camera to record, and we know that the image on the film is extraordinary.

David Finn.
Late Afternoon.
San Juan. 1980

I had a similar experience when I visited the campus of Hebrew Union College in Jerusalem, designed by the architect Moshe Safdie. It seemed to me that Safdie had used the brilliant Jerusalem sun as an element of his design, and the shadows thrown by the forms were as striking as the forms themselves. In some areas the shadows looked like stripes on the walls; the stripes changed direction as the sun moved across the sky. In other areas round openings in the walls cast sunlit projections that were part of the composition. Following the sun and shadows with my camera over the course of a day was a

Ralph Steiner. Mozart. Vermont. 1970—75

David Finn.
Hebrew Union College.
Jerusalem. 1989

great adventure, and I was sure that Safdie was a genius to have figured out how to create such brilliant effects with the moving light in the sky.

Once one begins to look at shadows a secret world opens up to one's eyes, for shadows can create the most remarkable shapes. This is particularly true when the sun is low in the sky, creating long shadows that mingle with other forms in one's line of sight. An image that has long stayed in my mind is a photograph I took at the end of a day of a lovely decorative iron grating—perhaps once put there for a lamp in front of a building—casting its long

**David Finn. <u>Bach</u>.
New York. 1984**

shadow across the stuccoed wall under a single window frame (p. 92). Even more haunting for me is a photograph by Ralph Steiner that has been hanging over my desk at home for years; in it a fledgling tree in winter, with a few dried leaves still hanging on to branches, throws its long spindly shadow on the snow while the heavy shadow of what looks by comparison to be a giant tree in the distance enfolds it in a sort of embrace (p. 93). Steiner called the photograph *Mozart* because of its beautiful melodic qualities, and I never tire looking at the strong black lines of the little tree surrounded by the soft, gray shadows that dance around it over the snow.

Still another type of shadow that fascinates me is that made by structures in the city. One day I happened to take a photograph of the shadows underneath the "El" in New York—one of the few remaining elevated tracks still left standing. Here it is not the shadow itself that is the image, but the strips of sunlight that show through the structure and produce a pattern on the shadowy background. I am tempted to call this photograph *Bach*, as a

**David Finn.
Dancing Images.
New York. 1985**

companion to Steiner's *Mozart,* since I can almost hear the sound of a *Brandenburg Concerto* as I look at the musical notes of light composed contrapuntally on the print.

Closely related to shadows are reflections, and with the proliferation of glass as a building material in recent times, mirrored views of the world have become everyday fare for walkers in the streets. Again we hardly take notice of them since it is the structure of the building we tend to look at, not its reflection in windows or glass exteriors, but once we are sensitized to the fantastic shapes we can find on reflecting surfaces—sometimes even on the curved windows of automobiles parked on the street—we are treated to a panoply of surrealistic images. Sometimes even in interiors, with windowed walls on opposite sides—as I once found in an escalator in a department store on which my wife was descending after doing some shopping—there is a surrealistic effect.

Many unusual discoveries have been made by a talented photographer named Amanda George, whom I met when I was taking photographs for a book on Villa I Tatti, the home, library, art collection, and gardens in Settignano, Italy, given by the art historian Bernard Berenson to Harvard University as a study center. Amanda is the librarian of Villa I Tatti, and one afternoon the fellows of I Tatti and I were invited to see a slide show of some of Amanda's photographs. I learned that Amanda had had several "solo" exhibitions of her photographs and had taught advanced photography in Florence. She had a superb eye, and I found her photographs truly remarkable. On subsequent visits I always checked in with Amanda to see what was new in her photographic adventures, and one day she showed me some stunning photographs she had taken of nearby scenes. One was a beautiful view of the valley near Siena—Val d'Orcia–S. Quirico—with July hay bales sprinkled on the rich green fields. Another was a detail of what she called "The Vasari Bridge," which is more widely known as the Ponte Vecchio in Florence (Vasari designed the upper part of the bridge). A third was a detail of a green cabana at Rimini with a shadow

**David Finn. Shopping.
Rio de Janeiro. 1992**

providing an undulating contrast to the horizon of the sea in midspring. When I complimented Amanda on the quality of the photographs, she said that she is frequently reminded by other photographers that she does everything "wrong"— wrong time of day, wrong lenses, and so forth. But somehow the results turn out well. She says she has no preconceived ideas when she goes out with her camera; she is simply attracted to colors found in nature and attempts to compose her photographs as simply as possible. I think she succeeds beautifully.

Different kinds of revelations can be found in photographs

taken through a microscope. This requires as much creativity as photographs taken with the naked eye, as was demonstrated by Roman Vishniac, a professor of biology and the humanities, who won acclaim for the wonderful abstract forms of his microscopic photographs as well as for his deeply moving photographs of the vanished world of the Jews of Eastern Europe. To call attention to the remarkable quality of such photographs, Polaroid conducts what it calls an "international instant photomicography competition," and in 1992 the grand prize was won by Gregory Paulson of Washington State University, Pullman, Washington. His photograph was taken of a feathery antenna of a male mosquito. Most of us think of a mosquito as something we try to slap before it bites, but Dr. Paulson shows us that there is a wonderful world of crisscrossing curves in a tiny section of its body that is a esthetically awesome.

None of these subjects is likely to attract the interest of the casual photographer. Yet they are all fascinating and exhilarating to look at. We might think of them as being in an invisible world, almost as remote as the world of antimatter, which we know we will never be able to see. Fortunately for the art of seeing, it is a world that the photographer has penetrated, and as a result, we know that the eye can be trained to find those revelations.

Gregory Paulson.
Mosquito Antenna.
Pullman, Washington. 1992

Stop in your tracks one day when you are walking down a path or along a street you have traveled thousands of times before, or when you are in a strange land looking at famous sights, and permit yourself to be astonished by the spectacular beauty of a small common something at which no one else is looking or perhaps has never been seen. You will become excited about constellations of lights and shadows, or nuances of color or textures, or forms that strike you as being spectacular, and you will have entered the world of revelations that photographers experience with their camera eye. The image itself will make an imprint on your mind, and the next time you see one of the great photographs of such a subject in a museum or a gallery or in a magazine or in a book you will know that the photographer has captured the essence of a hidden reality that you, too, are capable of seeing.

The Natural World

The legendary wonders of nature have held visitors spellbound throughout recorded history. People have traveled long distances to see them and been awestruck by their magnificence. And yet consistently through the ages, those wonders have failed to inspire great paintings. Most artists who tried to reproduce these sights in the past were overwhelmed by the grandeur of their subjects, and their natural instinct was to pay homage to nature's creation. This often led to aesthetic sterility and the slavish copying of nature's masterpieces rather than creative expressions of their own inner experiences.

The great landscape artists of the past have for the most part concentrated on pastoral scenes rather than natural wonders for their subjects. The Dutch artists of the seventeenth century, who were pioneers in landscape painting, were more interested in cottages and cows than famous sights and often saw more drama in the clouds of the sky than the contours of the land—which in their country was pretty flat. The same was true of the English landscape painters of the eighteenth century, the French Barbizon painters, and the painters of the American Hudson River School in the nineteenth century. They would all have resonated to William Wordsworth's ideas about the beauty of all of nature, whether commonplace or grand, as expressed in "Tintern Abbey," in which he described himself as:

> A lover of the meadows and the woods,
> And mountains; and of all that we behold
> From this green earth; of all the mighty world
> Of eye, and ear,—both what they hold create,
> And what perceive . . .

**William Henry Jackson.
Grand Canyon
of the Colorado.
1870–80**

Among the most passionate of landscape painters were the artists who discovered the joys of painting outdoors—Corot, Cézanne, Pissarro, Monet, Van Gogh and others; but they had no interest whatsoever in the spectacular. Renoir once said "Give me an apple tree in a suburban garden. I haven't the slightest need

of Niagara Falls." Landscape painters of China and Japan did choose mountain scenes as their subjects, but their works were impressive because of their delicate technique not because of the grandeur of the landscape. The two great Swiss artists who cherished the mountain scenes of their country—Giovanni Segantini and Ferdinand Hodler—created strong and colorful paintings that are stunning because of their painterly qualities rather than their awe-inspiring subjects. That was also the case with America's Georgia O'Keeffe, who loved the beautiful mountains and deserts of the American West but produced works that could have been painted anywhere.

This circumstance changed almost overnight with the advent of photography. Suddenly there were artists who found a new way to portray the great phenomena of nature, and their photographs proved to be as remarkable as their subjects.

Many of these great landscape photographs were taken just a few decades after the invention of the photographic process in 1839. Photographers all over the world started photographing the awesome sights of their countries. Perhaps the greatest achievements were made by photographers who traveled to the American West on photographic expeditions to explore the mountains, canyons, deserts, waterfalls, and other natural phenomena they found on the new frontier.

These landscape photographers of the nineteenth century, who were making the most of the new art medium, discovered that when they pointed their cameras at spectacular natural phenomena they could frame in their lenses wonderfully striking compositions. The photographs they took are compelling not only because they captured the awesomeness of their subjects, but because they found a way of looking at those subjects with a fresh eye. Their approach was different from painters of famous places whose quest for verisimilitude stifled their originality. The photographers of the nineteenth century were artists who were liberated from the task of reproducing the wonders of nature—their cameras did that for them. They could concentrate their creative efforts on exploring the awe-inspiring scenes

for striking compositions that when captured on film would produce dramatic works of art.

One of the most impressive of these photographers was Timothy O'Sullivan. In 1872 he took a remarkable photograph called *Vermilion Creek Canyon* that shows what an incredible eye he had. He found a spot between two cliffs—one in deep shadow and one in sunlight—that when seen together makes a marvelous composition. The shadow of the cliff on the left is cast on the valley below, and in its midst there appears to be the remnants of the creek with water reflecting the bright sky above. This could almost be a photograph of a monumental sculpture in which the photographer reveals the superb forms created by the artist. But in this case the subject is nature itself, and the work of art is what the eye of the pho-

Timothy O'Sullivan.
Vermilion Creek Canyon.
1872

tographer observed, which makes his discovery an especially outstanding aesthetic achievement.

The Grand Canyon is one of the most spectacular sights in the world, and anyone who has been there is overwhelmed by the cavernous spaces and the infinitely varied forms seen as one looks downward into the tiny Colorado River below. Joseph Wood Krutch described it as "the most revealing single page of earth's history anywhere open on the face of the globe." But photographing this unique formation is a formidable challenge. There have been some magnificent color photographs taken in our time by Ansel Adams, Philip Hyde, and others, but a black-and-white photograph taken in the nineteenth century by William Henry Jackson was an especially remarkable achievement. He singled out a dramatic overhanging cliff that appeared as a monumental dark form in the foreground, with the scene below barely visible because of the incredibly bright sunshine. The contrast of the dark and light as well as the shape of the enormous rock produced a monumental effect. The tiny figure of a man with a telescope to his eye, and another resting on a rock behind him, gives a sense of scale to the whole scene (p.100).

One need only look at the glossy photographs in calendars and postcards of the Grand Canyon, Yosemite Park, or the California Redwoods to see that photographs that do no more than show a spectacular scene are not necessarily works of art. It is not the awesome sight itself which results in a great landscape photograph; it is the creativity of the photographer who finds in an awesome sight a combination of lines, textures, shapes, and nuances that produce an aesthetic image.

It is impossible to write about the art of landscape photography without giving due credit to Ansel Adams, who was one of the greatest practitioners of them all. Adams devoted most of his adult life to traveling throughout the western part of the United States, taking some of the most magnificent photographs ever created. And "created" is an appropriate word, for somehow it seemed as if he not only discovered beauty in the breathtaking scenes he photographed, but he managed to put his soul into

Charles Phillips.
Torrey Creek.
Fitzpatrick Wilderness,
Wyoming. 1982

104

each of the images that came out of his camera. It is often said that his musical training may have had something to do with his remarkable eye for the harmonies of nature. He also invented what he called the "zone system" to measure the intensity of the different light sources of a scene as a guide in both lens settings and printing, which was in itself something of a technological breakthrough. However much these contributed to his success it was his genius that enabled him to create magnificent landscape photographs.

A whole school of new photographers now follow in Adams's footsteps. A remarkable example of this new generation is a young man named Charles Phillips who lives in Caldwell, Kansas, and who specializes in what he calls "wilderness fine art photographs." Some years ago his work was exhibited in Wichita, but for the most part he sells his prints to individual collectors. I met him one day in New York when he called at the suggestion of a mutual friend and asked if he could show me some of his wilderness photographs. I agreed, and to my surprise he arrived with several large cases and an easel with lights and a transformer. He opened one of the cases and placed a large, 3 x 4', framed, black-and-white photograph on the easel with a spotlight attached above. It was a magnificent print of a waterfall, with sunlight highlighting the foam, and every streak of water reproduced with brilliant clarity. The details of rocks and trees seemed to be etched into the print. I was astonished at the quality of the photograph, and even more intrigued when Phillips adjusted the spotlight with the transformer to show me different effects when the light was brighter or softer. He then showed me spectacular photographs of mountain scenes and held up a magnifying glass on one to help me see tiny figures in the snow. He described his experiences in trekking through the wilderness for days to find the views he wanted to photograph. He also took out a picture of the equipment he had built to make these large prints and explained his procedure of masking different parts of a negative to get the exposure he wanted for every part of the print. He worked with three assistants, eight hours a day, five days a week, sometimes for as long as seven weeks to make a single

print! I was incredulous. But the results were marvelous, and I congratulated Charles Phillips for his extraordinary achievements.

This approach to landscape photography is quite beyond me. My interest is more impulsive and far less studied. I look at landscapes almost as sculpture, and I try to capture the forms I see as if they are works of art. I have been captivated by many beautiful places in my travels around the world—the ancient hill towns of Italy, the awesome heights of Delphi, the towering peaks of Switzerland, the timeless hills of Jerusalem, the green pure lands of New Zealand, the spectacular coastline of Rio de Janeiro. But it was when my family traveled to the highlands of Scotland that I had my first real introduction to the art of landscape photography.

In an article I wrote for the British Journal of Photography I described how the highlands had taught me to photograph landscapes. We had in earlier years been to Dumfries, where I photographed Henry Moore's *King and Queen* sitting like prehistoric royalty overlooking the Scottish lowlands. But even this dramatic sight did not prepare me for the spellbinding scenery of the highlands—the rich green colors of the fields contrasted with the great barren rocks jutting into the air and streaks of stone or grass

David Finn.
The Highlands.
Scotland. 1975

streaming like lava over the mountainous landscape—that we saw driving north from the lovely Loch Lomond and passing through Crianlarich and the Glencoe Pass. I had not been interested in taking landscape photographs before, but I couldn't resist climbing up the side of the ravines and struggling to fit the enormous spaces into the view glass of my camera.

Around the small town of Kinlochleven on the very still and spectacular Loch Leven, a lovely tree on a small island took my breath away. Capturing that sight in my lens was a moment of unforgettable triumph. Later, the legendary Isle of Skye, our destination on our first trip to the highlands, lived up to its glorious name. It was a place of mystery and unspeakable beauty. It didn't matter there (or

elsewhere in the highlands) whether it was sunny, rainy, or misty (we had it all); it is one of the few places in the world that was marvelous to be in no matter what the weather is like.

On subsequent trips we visited the sacred Isle of Iona, which seemed to have a spiritual quality in every inch of ground (I even picked up some stones in the fields, which I still treasure). The islands of the Outer Hebrides, Lewis and Harris, were more remote and stark. But the far north of Scotland was glorious. Cape Wrath, with its amazing sandy beaches and the mountain ranges in the distance, was like a separate reality, which I tried my best to capture on film.

The ferry from John O'Groats to the Orkneys, past the cliffs of Hoy, was a supreme moment. My wife couldn't help being a little scornful when I took my camera out to photograph the cliffs. "Just like a tourist," she said accusingly, as if my purpose was to take the kind of snapshots that others on deck were taking, with

**David Finn. Cliffs.
Isle of Hoy,
the Orkneys. 1975**

David Finn.
Skyline at Sunset.
New York. 1980s

the scenery as background for photographs of friends and family. But to me the cliffs were like giant sculptures carved by nature, and I was thrilled to have a chance to photograph them.

Since then I have used my camera to record panoramic views whenever the spirit moves me. Once I was visiting Henry Moore in his home in Much Hadham, England. It was late afternoon in the middle of winter. Moore looked out the window of his living room at the setting sun and said, "Quick, David, get your camera." I did, and photographed the red glow in the sky, which was particularly beautiful at that moment. Henry Moore died a few years later, but the photograph of that afternoon sunset that he loved so much is one I still treasure.

The end of a day is always particularly inviting because of the wonderful light one sees at dusk. I remember reading the possibly apocryphal story that Leonardo liked that time of day to work on his paintings; I find that it's a great time to have my camera with me. One can never anticipate what the sky will look like as the colors begin to change. Once I was able to catch a remarkable red glow behind the buildings I could see from my office window. Another time, walking in the early evening when the street was almost dark, I looked up between the buildings and saw the amazing shape of an inverted, elongated pyramid in which darkening sky still glowed.

Below: David Finn.
City Canyon.
New York. 1980s

Bottom: David Finn. **I Tatti**.
Settignano, Italy. 1990

110

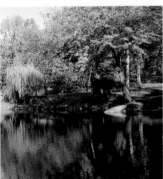

Left, above: David Finn.
<u>Central Park Underpass</u>.
New York. 1982

Left, middle: David Finn.
<u>Central Park Lake</u>.
New York. 1982

Left, below: David Finn.
<u>Through Henry's Window</u>.
Much Hadham, England. 1970s

Below: David Finn.
<u>Irina's Garden</u>.
Much Hadham, England. 1980

I found a similar inverted pyramid of the sky in another part of the world when I was taking photographs for a book on Bernard Berenson's Villa I Tatti (p. 110). Around the villa are marvelous gardens that Berenson loved to walk in and which are maintained beautifully today by Harvard University. In one section there is a long path with rows of enormous cypress trees on both sides, and the photograph I took of the path was reminiscent of the canyon of my New York City scene.

Gardens and parks can be inspiring subjects for the camera eye, and I have enjoyed photographing jungle-like thickets of South American parks as well as manicured lawns and foliage in European gardens. *In Irina's Garden* was the name of a book I helped to publish as a tribute to Henry Moore's wife, Irina. Over a period of years, I took photographs of her garden to show her how much I loved her, and she was always pleased to see the results of my work (p. 111). I had the idea of publishing the photographs as a book, but for a long time she was too retiring to consider it seriously. Finally, when I suggested that the Moores' friend Stephen Spender write the text for such a book, and that the publisher Thames &

David Finn.
Storm Over Puerto Rico.
Puerto Rico. 1979

Hudson would be interested in producing it, she consented. I was delighted with the result, and I know she was as well.

One park that has had a special place in my heart has been Central Park in New York, the masterpiece of the landscape architect Frederick Law Olmstead. When I was a boy I used to love to roam through the park and make sketches of the trees and rocks. In recent years I have been driving through the park on my way to my office, and I am constantly baffled as to how it became such a beautiful place. I have seen public parks in cities all over the world, and to my eyes none can compare to the natural beauty of New York's Central Park. Some parts look as they have been untouched by human hands, much less a landscape architect, with trees and bushes growing in the purest natural harmony. Other sections have the grandeur that makes the Lake Country in England so magnificent. And the occasional stone arches that are made for walkways look almost as if they were hewn out of rock (p. 111).

I had a different experience when driving through the mountains of Puerto Rico with some friends. The weather had been lovely and we were enjoying the landscape, when suddenly the sun disappeared and we became aware that storm clouds were swiftly covering the sky. There was an eerie light over the mountains, and I stopped the car to photograph the scene. I printed

that photograph when I returned home, and it turned out to be one of my favorite landscape shots.

Still another photograph I took in a strange light was from the window of the home of the president of Iceland. I was there on a visit some years ago and was fascinated by the light coming from the sun which was low in the sky in the late evening. The simplicity of a nearby house, with the sun behind it throwing a deep shadow on the ground, and the snow-covered vistas in the background, had a haunting and beautiful quality (p. 113).

**William Baker.
Palmer Peninsula,
Antarctica. 1992**

**William Baker.
North Pole. 1993**

Friends of mine often show me photographs they have taken on their travels, and I have been impressed by their quality. Among the most remarkable I have seen were those taken by Bill Baker, the president of the public television station in New York, WNET, and one of the few individuals who have been to both the North and South Poles. He has taken some spectacular shots on his different trips. These are landscapes I have never seen, but Baker's photographs give me a sense of being in these remote parts of the world.

Among the most jewel-like landscape photographs I have ever seen are seascapes rather than landscapes. They were taken from a helicopter by Harvey Lloyd, who is probably the most accomplished and inspired aerial photographer of our day. Over a period of many years he has taken thousands of photographs from a helicopter in all corners of the world. He has a photographer's dream assignment—to follow the voyages of the Royal Viking cruise ships as they move across the seas to their different destinations and photograph from the air the gorgeous scenery in which the ships sail. He has taken photographs at all times of the day and in all seasons, and his prints are often as spectacular as stage settings. They are almost too beautiful to be believed.

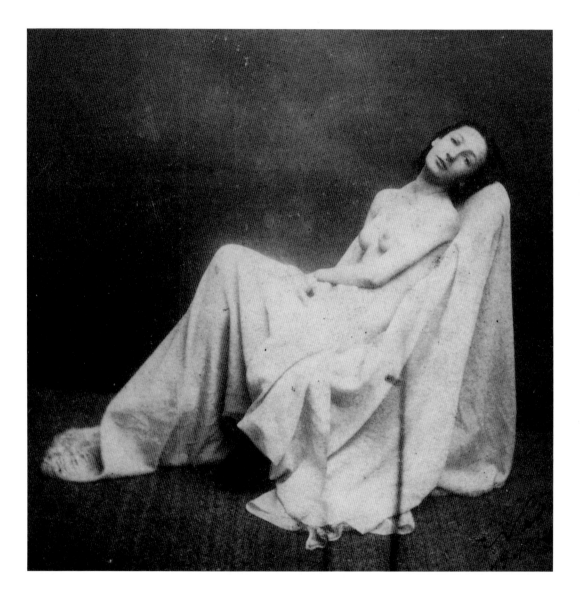

The Landscape of the Naked Body

It is not as long a step as one might think from the landscape of nature to the landscape of the naked body. Both involve forms that fascinate the eye, but for different reasons. Nature's awesome wonders bring us into the presence of what we may think of as the divine in the world around us. The human body contains the reality of living flesh, and its wonders bring us into the presence of what we may think of as the divine in the world within us. "The human body," Auguste Rodin once said, "is above all, the mirror of the soul, and from the soul comes its greatest beauty."

Poets have long seen a commonality between the flesh and bones of human existence and the world around us, both, as Shakespeare put it, "cheared and checkt even by the self-same skie." But they also celebrate the spirit within us that distinguishes us from the rest of nature and endows our physical beings with a sense of beauty. That is perhaps what is meant by the unanswered questions in that wonderful stanza of *The Book of Thel* by William Blake:

Does the Eagle know what is in the pit?
Or wilt thou go ask the Mole?
Can Wisdom be put in a silver rod?
Or Love in a golden bowl?

Blake's drawings are filled with naked figures representing spirits, fairies, gods and goddesses, mythological and biblical characters, since for him the human body is the transitory receptacle of the eternal soul. Other spiritual ideas are expressed in many ancient religious images involving the naked human body—in India, Cambodia, Egypt, Greece, Rome, and Africa, as well as in paintings and sculptures in Christian churches around the world.

The sexual aspect of religious representations of naked figures, which is often quite explicit, is not inconsistent with their spiritual intent, for sex in the minds of these artists and their the-

Felix Nadar.
Seated Model,
Partially Draped.
c. 1856

ological mentors is very much part of the generative powers of the universe. The fact that sex is pleasurable is one of the most highly appreciated (although sometimes highly condemned) benefactions of the Almighty.

The nude in photography carries on this tradition in a modern idiom. There is no longer any religious connotation, but there is a strong poetic sensibility. Some aesthetic wire in our brain is tuned to the melodies of human anatomy, and when it starts to vibrate we see endless variations of sheer loveliness. Walt Whitman referred to the phenomenon as "The Body Electric" and wrote passionate lines about the bodies of a man and a woman:

> The love of the body of man or woman balks account, the
> body itself balks account,
> That of the male is perfect, and that of the female is perfect. . . .

> This the female form,
> A divine nimbus exhales from it from head to foot,
> It attracts with fierce undeniable attraction.
> I am drawn by its breath as if I were no more than a helpless
> vapor, all falls aside by myself and it,
> Books, art, religion, time, the visible and solid earth, and what
> was expected of heaven or fear'd of hell, are now consumed,
> Mad filaments, ungovernable shoots play out of it, the response
> likewise ungovernable,
> Hair, bosom, hips, bend of legs, negligent falling hands
> all diffused, mine too diffused. . . .

> The male is not less the soul nor more, he too is in his place,
> He too is all qualities, he is action and power,
> The flush of the known universe is in him. . . .

> Examine these limbs, red, black, or white, they are cunning in
> tendon and nerve,
> They shall be stript that you may see them.

> Exquisite senses, life-lit eyes, pluck, volition,
> Flakes of breast-muscle, pliant backbone and neck, flesh not
> flabby, good-sized arms and legs,
> And wonders within there yet.

Even though Whitman was a hedonist, he deplored popular literature that was "sickly, scornful, crude amorousness." But since photographic images can be made by anybody of anything, the invention of the camera led not only to a new aesthetic of the

nude but also to the making of pictures strictly for lewd purposes. These are inspired by the voyeuristic pleasures of nudity, and were once sold on the street as "dirty" postcards. Now they are commonplace in magazines found on every newsstand. Unfortunately they are also typical of many photographs of nudes taken by some popular professional photographers.

What we call here the naked landscape refers to the artistic or what our ancestors might have called the spiritual aspects of the human figure. The difference between a great photograph of a nude and a *Playboy* photograph is immediately obvious: the former has an enduring quality in which the beauty increases the longer one looks at it; the latter is worth but a passing glance.

An early example of a nude photograph that is rich in mystery and poetry was taken by Nadar, the pseudonym of a nineteenth-century Frenchman, Gaspard-Felix Tournachon (p. 116). Dated c. 1856, the photograph shows a partially clad figure of a seated young woman, her head leaning gracefully on the back of a draped chair, with one knee raised, her hands crossed on her lap, a soulful look in her eyes. The full image, which includes not only the figure of the woman but the drape falling on the floor, is composed with great sensitivity. There is nothing lewd about the photograph, but the fact that the figure is at least partially naked is an essential part of its beauty.

A photograph by the American painter Thomas Eakins taken in the 1880s shows the practice in that prudish era of covering the faces of models with a cloth. This was just a generation after Hiram Powers's famous sculpture *The Greek Slave* was toured around the United States in exhibitions that sometimes prohibited men and women being admitted together. Eadweard Muybridge's landmark photographs of nudes in motion, taken about the same time, were revelations of how the body looks as it moves, and his strips of photographs showing figures in motion are fascinating to study.

When Edward Steichen, Alfred Stieglitz, and Clarence White turned their cameras on the naked body, we began to see new kinds of forms that had a character of their own. One of Steichen's

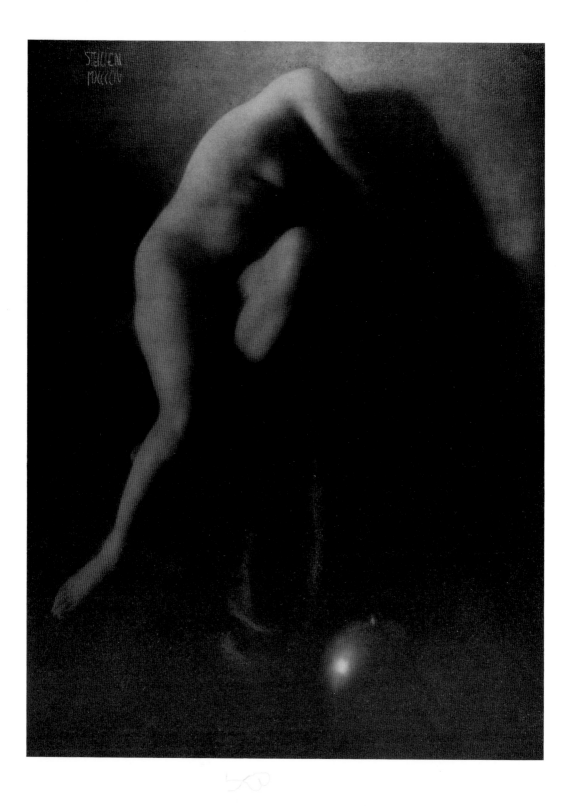

photographs is a frontal view of a woman seated in what seems to be a contorted position with one knee raised and the other leg slightly bent, one arm reaching out as if to hold herself steady, and her head, with long dark hair streaming down, tilted to one side. What is so remarkable about this photograph are the highlights dramatizing the contours of the woman's body in an extraordinarily graceful composition. Even if one turns the photograph upside down it is perfectly composed—with the little highlight on the ball below playing an important role in maintaining the balance in the picture.

Edward Weston.
<u>Nude</u>.
Mexico City. 1925

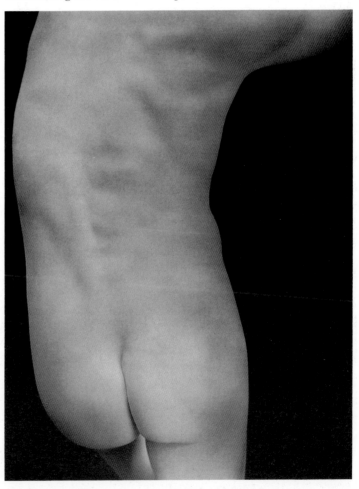

Opposite:
Edward Steichen.
<u>In Memoriam</u>. 1906

It was Edward Weston who achieved the greatest heights in photographing the body as landscape. He often concentrated on anatomical details rather than the body as a whole to produce the most magnificent images. He must have worked as hard on each shot as he did on his famous pepper. In one instance, the back view of a photograph of a male figure shows the torso twisting to the right, with the beginning of an outstretched arm seen at the top (p. 121). The sinuous line of the body rising from the buttock to the shoulder on the left of the photograph is amazingly graceful, and the line on the right where the arm balances the opposite buttock is equally beautiful. The subtle shadings of the flesh make the photograph more than simply a design and give the forms added strength.

It has always struck me that these abstract photographs of nudes teach us to appreciate the delicate forms of the bodies we love. They are not erotic; their purpose is not to stimulate. But they are expressions of a photographer's response to a figure that for personal reasons has a strong sensuous appeal.

We have to remember that Walt Whitman was not writing about pulchritude in "The Body Electric," and we have no reason to believe that models for the great photographers of the naked landscape were especially attractive. It is one of the illusions, perhaps exacerbated by what we see on film or television or in our popular magazines, that our eye for sensuous form can only be excited by figures that meet a prescribed standard.

My camera has taught me to see with the poet's eye a beauty that exhales "a divine nimbus" in every detail of "the body electric." I have learned to see this in the highlight falling on a portion of a ribcage. To me it is a gentle hill in the landscape of the human body, glimpsed through the dark shadows of dawn, just as the sun is rising. In another view there is a geometric design created by the slightly curved horizontal line of a belly, with the oval of the navel providing a fine counterpoint. Elsewhere my camera frames the upper thighs as they meet the buttocks, and the curving lines make a lovely composition as they interweave with each other, with a slight deepening of a shadow in the cen-

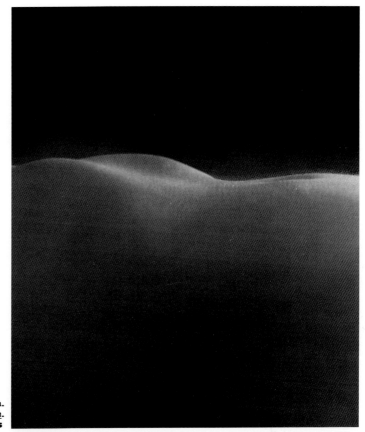

David Finn.
Gentle Landscape.
1980s

ter giving emphasis to the forms. A fourth detail shows the round curves of two breasts resting on an arm. And a fifth is almost a picture of flesh itself, as a raised thigh creates subtle shapes and shadows that delight the seeing eye.

As an experiment, to show that such views can be found by anyone with a perceptive eye, I made a series of prints of photographs taken some years ago by my then sixteen-year-old daughter Amy after she returned from a summer photographic workshop in Aspen, Colorado. One of her projects had been to spend a few hours alone with a nude model in a field, shooting away to her heart's content. I thought some of her negatives were lovely, and that with careful cropping I made prints that showed what a good eye she had.

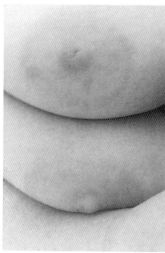

Top Right: David Finn.
Interweaving. 1980s

Below: David Finn.
Geometry. 1980s

Bottom left: David Finn.
Flesh. 1980s

Bottom right: David Finn.
Two Curves. 1980s

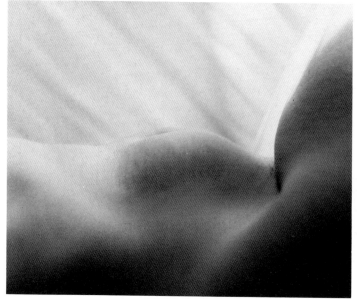

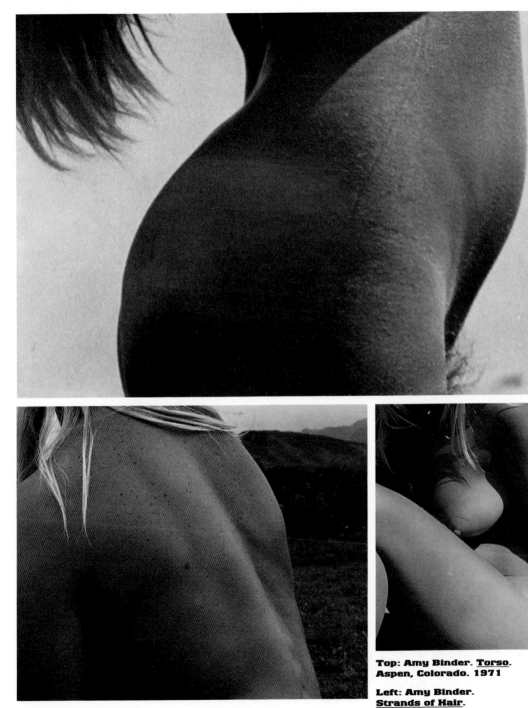

Top: Amy Binder. <u>Torso</u>.
Aspen, Colorado. 1971

Left: Amy Binder.
<u>Strands of Hair</u>.
Colorado. 1976

Above: Amy Binder.
<u>Crouching</u>.
Aspen, Colorado. 1971

A friend of mine, Maurizio Ghiglia, who lives in Florence, has produced a series of nude photographs that I find particularly fascinating. I met Maurizio some years ago through his friend, Barbara Antonelli, a gifted young painter who has been a great help to me on a number of my photographic projects. Maurizio's work is primarily in theater and ballet, and he has probably photographed every important actor and dancer who has performed in Florence. But he also takes from time to time creative photographs of the nude, revealing the rhythm of a figure sprawled on a sheet in ballet-like postures. He has a remarkable eye for form—and also a delightful sense of humor, as can be seen in the photograph showing the nude figure peeking out from the top of the print.

Photographs of the full nude can also be gloriously simple. Such is the case with the photograph by George Platt Lynes of a young girl standing on what seems to be a ledge, her legs apart, hands at her sides, her face—with a serious expression—looking down. The sky is dark above and becomes brighter on the horizon; the light coming from the left suggests the morning sun, bringing out the subtle modeling of her figure. She seems completely at ease with her nudity and the beauty of her youthful body.

Robert Mapplethorpe was a master in portraying the human figure, and his many photographs of male models are superb.

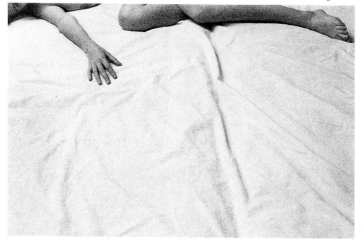

**Maurizio Ghiglia.
Peeking Nude.
Florence. 1990s**

126

George Platt Lynes.
Untitled. c.1930

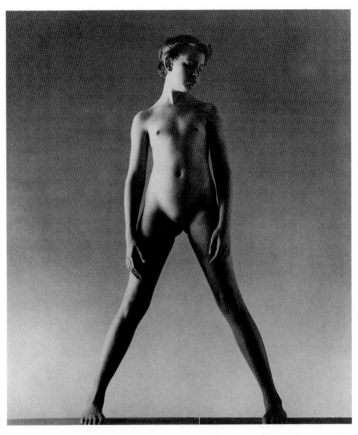

His feeling for the male figure equaled that of the Greeks, who idealized clean, muscular, athletic forms of men who looked like Olympic champions. The ancient sculptures of discus throwers and boxers matched those of the gods. Mapplethorpe selected models who had bodies as perfect as those of the Greeks, and his pristine photographs have a classical purity. In his photograph of Ajitto, one of his models, sitting on a table with his head touching his raised knees, arms clasped in front of his shins, the muscular body glistening in the light from his rear, we see a figure that deserves a place in the pantheon of the gods. The classical feeling of the pose is heightened by the cloth covering the table, its creases carefully arranged to resemble the lines of a Greek column (p. 128).

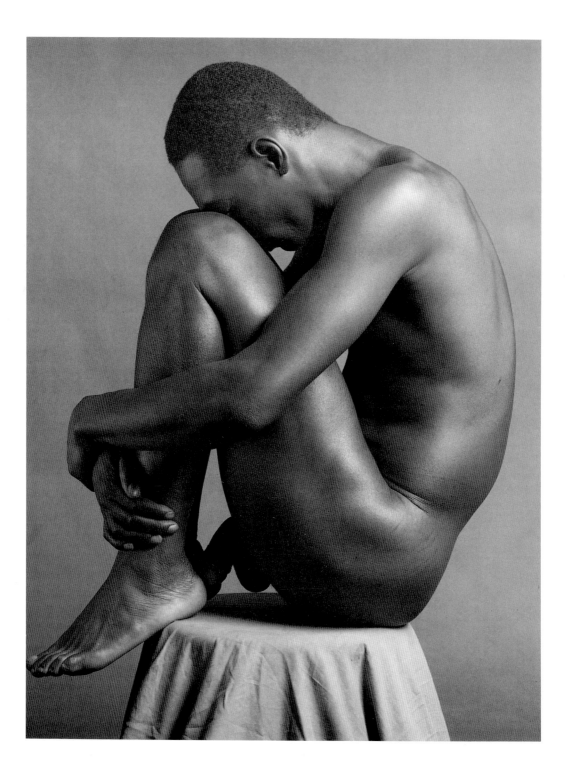

A photographer of a different sort who created masterful pictures of the nude was Manuel Alvarez Bravo. He had a mythical concept of the nude that had its origins in the tradition of Xipe Totec, the flayed god who was the symbol of the earth's renewal. In several of his photographs a naked girl is partially wrapped in fabric. As can be seen in the photograph called *The Unbandaging*, the effect is magical. Somehow there is a mystery in the pose of the young woman, with her two

**Right: Robert Laurie.
Untitled.
New York. 1990s**

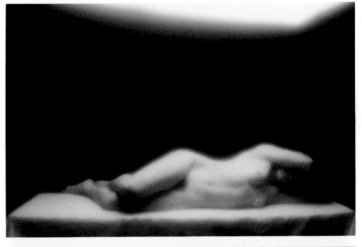

**Deborah Turbeville.
Steam Bath. 1984**

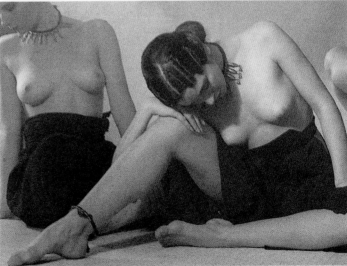

**Opposite:
Robert Mapplethorpe.
Ajitto. 1981**

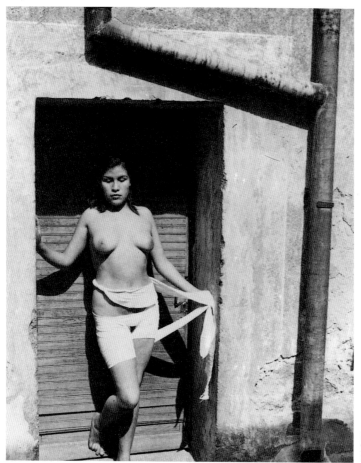

Manuel Alvarez Bravo.
The Unbandaging.
Mexico City. 1938

arms outstretched, one of her feet leaning against the door, the "bandages" unraveling in her left hand, the downward glance suggesting a strange preoccupation. A haunting photograph, it is one of Bravo's most striking images.

Some photographers have developed special techniques to project the fleshiness of a nude figure. Bob Laurie has been particularly successful in this respect through the use of filters, the careful focusing of lights, the creative posing of models, and the cropping of negatives to achieve dramatic compositions. His soft-focus prints against dark backgrounds, with modulated shadows offset by geometric bright areas, achieve a

dramatic impact. His are almost painterly nudes; they convey the feel of the flesh as well as its subtle undulations (p. 129).

A surreal effect can be found in a series of photographs by Deborah Turbeville that she calls *Les Amoureuses du temps passé*. There is a sensuous quality in her photographs; many of the women are partially clad, all are somewhat pensive. The flesh tones that are revealed in the highlights seem rich and palpable against the soft shadows, and the position of the figures enhances the gentle quality of the photographs. One particular photograph of two young women with similar physiques, and equally graceful postures, has a muted quality, almost as if flesh tones have been added to a black-and-white photograph (p. 129).

These many variations of the landscape of the naked body make it clear what a fertile subject it is for the eye of the photographer. The possibilities are endless. Great photographs of the nude have been taken by Lucien Clergue, Paul Strand, Brassai, Man Ray, André Kertész, Bill Brandt, Harry Callahan, Duane Michals, Diane Arbus, Minor White, Paul Outerbridge, Jr., Dorothea Lange, Imogene Cunningham, and many others. Photographs by lesser known photographers are equally remarkable, like those by E. J. Bellocq taken in the brothels of New Orleans. And still others exist by anonymous photographers, such as those in the collection of more than one hundred prints that was discovered in 1975 in a flea market in Mexico City; they were apparently taken just after the turn of the century in what was called the *casa de cita*, a house of prostitution similar to a French bordello. Some of these were interior shots and others were taken in landscape settings; many are extraordinary. Similar collections have been found in France and Italy, and I have heard of others in England, Scandinavia, and the Far East.

The naked landscape is perhaps the only subject that nonprofessional photographers cannot easily explore, but it is one that all lovers of fine photographs can appreciate. And looking at beautiful photographs of the nude is certainly one of the ways in which our eyes can be educated, the art of seeing can be mastered, and our aesthetic lives enriched.

Moments of Being

At the end of her book *Orlando*, Virginia Woolf writes that "there is a touch of hallucination about 'reality.'" We sense that strangeness in photographs that capture fragments of time that we never visualize on our own as fixed images. To borrow another phrase from Virginia Woolf, these "moments of being" are surreal when caught by the eye of the camera and frozen on film.

Sometimes photographs tell stories about a moment of being that a photographer may have only vaguely understood when he or she snapped the shutter. I don't know what prompted me to take a street photograph of a family on a Harlem sidewalk—perhaps it was the flashing impression of the pretty young girl standing on the sidewalk, looking wistfully into the distance. I had no time to compose the photograph—its virtues in that regard were either intuitive or sheer luck. Afterward, I saw the frown on the face of the boy and wondered what was the matter; I also saw him fondling one of two dogs sitting on the ground. I noticed that the mother (or grandmother) is looking up from her paper at the boy with a concerned look on her face. Had he been crying? Had she just scolded him? Is she worried that he might run off? The other little girl is oblivious to what is going on and looking at something in the other direction. Why is the family sitting there? Are they just resting? Are they waiting for something or somebody? What is the empty cart and the wooden ladder doing in front of the store? What kind of store is it (one of the signs says "Pipes cut to sketch!")? The impact of the photograph, for anybody who looks at it closely, is heightened by all those unanswered questions. It represents a slice of life in which the true story of what that moment represents might fill a volume.

A camera can stop in mid-air actions that we see as continuous motion. Barbara Morgan's fabulous photographs of dancers capture forms that can hardly be seen with the naked eye, and yet in the instant that the shutter opened, that is exactly how the dancers looked. Her photograph of Martha Graham's

David Finn.
East Harlem.
New York. 1982

Barbara Morgan.
Letter to the World.
1940

performance in "Letter to the World" is a portrait of a great dancer; it is also a work of genius in its own right. We see the dancer with one foot touching the ground in a position that could not hold her body more than an instant, the other foot thrust upwards, the folds of her dress fanning out in a shape that is marvelous to behold. No one who watched Graham dance would have been conscious of precisely what Morgan's camera captured. But we all enjoy her photograph as the epitome of grace.

Another photographer of dancers, Herbert Migdoll, focused on views that captured the spirit of his subjects as well as the drama of a particular moment in time. One of his ideas was to photograph the Pilobolus dancers on the rocky seacoast of Newport, Rhode Island. But when he saw their regular choreography outdoors he felt it didn't work out as he had hoped. He asked them instead to create a new movement related to the environment, and the result was a moment choreographed just for his camera. It enabled him to create a remarkable photograph, with the warm flesh color of the three bodies sitting on top of each other, each in a slightly different position, producing an arresting effect against the rough gray rocks (p. 136).

Photographs of moments of being are often found in daily newspapers or magazines showing people in motion. We are so used to seeing such photographs we hardly realize what a remarkable achievement it is for the photographer to catch a subject at the precise moment that will produce an exciting composition. As can be seen in some of Maurizio Ghiglia's fine photographs of ballet dancers, the eye has to be alert to snap the shutter just as a figure is bending over in a contorted position, or moving her arms and hands in a graceful sweep around her body. Such photographs show the relationship between the arts of ballet and sculpture; the camera transforms the beauty of movement into the beauty of monumentality.

Great photojournalists have taken some of the most astonishing photographs from all sorts of vantage points. One that I find particularly spellbinding was taken by Robert Capa on the Rhine River in 1945, when the U.S. 17th Airborne division parachuted into Germany together with a British airborne division. The sky was dotted with men floating to earth in the heart of the last German defense line as the war was coming to an end (frontispiece).

Animals in the African bush sometimes form groupings that look too good to be true. One by Charles Lipton, taken on a safari on the plains of Maasai Mara in southwestern Kenya, shows

Herbert Migdoll.
Pilobolus.
Newport,
Rhode Island. 1973

two elephants fighting each other. It is a sight that could never be set up by a guide; the photographer just has to be there at the right moment and be ready to aim a camera the instant an exciting opportunity arises.

In the jungle of urban life, one finds different kinds of animals fighting each other—human animals. Once I was walking down a street minding my own business when suddenly I became conscious of a scuffle. A taxicab had stopped in front of a red traffic light and a passerby had apparently knocked the side of the car

Charles Lipton.
Elephant Fight.
Kenya. 1991

William Baker. Seal.
Antarctica. 1992

with his knuckles. I didn't know the passerby's motivations, but the taxicab driver was furious; he jumped out of his car, grabbed a mean-looking club that he must have kept in his cab, and started beating the passerby unmercifully. The driver was short and wiry, the passerby tall and powerful, and before I knew it the latter had the former by the throat. I whipped out my camera and was able to get a shot of the two of them going at each other. Seconds later the police arrived on the scene and ended the fight. But I had my photograph of a violent street fight.

Once I had an idea of taking a series of photographs in the New York City subways. It was amazing to me how little attention was paid to me and my camera. People riding the subway are used to anything, and a man running around taking their pictures was a minor oddity at most. Also, people are thinking of other things—where they're going, where they've been, how they can avoid being jostled and pushed. In one photograph there was a view through an open door of a subway car, and the expression (or lack of expression) on the two faces staring at me seemed to convey perfectly the feeling of numbness that is characteristic of many subway-riding experiences—"distracted from distraction by distraction" in T. S. Eliot's telling phrase.

Action, stopped in a split second, is not the only technique for conveying an awareness of moments of being. Sometimes the world seems to hold still at a certain point, and what we see in that moment gives us some special insight. I can't help feeling that Bill Baker had such an experience when he photographed a reclining seal staring at him from its perch on a massive grouping of rocks in Antarctica. There was probably even less in the mind of the seal than my subway riders, but Bill Baker got a fine photograph out of that distant stare (p. 137).

When something is happening that one wants to freeze in a photograph, timing is crucial. Not long ago I stood on one of the bridges over the Arno River in Florence, Italy, watching a lone canoeist approaching. The water was very still and the reflections made by the canoe and the paddles seemed intriguing to me. I had only a small pocket-size camera with me, and I knew that if I

Top: David Finn.
Street Fight.
New York. 1984

Above: David Finn.
Subway Scene.
New York. 1982

took the photograph too early, the canoeist would be little more than a speck in the river, so I waited until he got close enough to see him clearly. The shot I thought would tell the story was when the canoe was just about to go under the bridge, but by way of preparation I took an earlier shot as the canoe was approaching the bridge. As it turned out, the photograph I thought would be the better one turned out to be dull, but the earlier one had a quality I never anticipated—the reflections at the edge of the photograph which gave the canoeist a physical context. On the right was a reflection of a giant crane that I wanted to keep out of the photograph because I thought it spoiled the scenery, and on the upper left there is just a hint of the buildings on the other side of the river. Now, as I look at the print, it has that same kind of mysteriousness as the family I photographed in Harlem. The sense that there is more going on than what is shown in the photograph is what makes it so provocative.

Another photograph that surprised me was taken in Campo de Santo, the grand open space in the heart of Siena. One day while walking across the ancient stones I became conscious of their harmonious pattern, and decided to photograph them. As usual the pigeons were in the way and I clapped my hands to scare them away. Most of them took off, but two stubborn pigeons refused to move. I tried to avoid them when snapping my picture, but when I looked at my negatives in the dark room I

found that they were still there at the top of the frame. To my surprise, I realized that they made the photograph far more interesting than would have been the case if they had flown away, and I made a print showing them strutting around as if they owned the place. In a way, my pigeons on the stone pavement were an echo of Ralph Steiner's two men looking at the ocean.

Sometimes one can read into a photograph a story of what happened in the past, and a moment of being becomes an archaeological remnant of another time. That is certainly true of signs on walls that are left over from an earlier day and are now totally incongruous with the surrounding area. Posters for movies, plays, or performers that are peeling off the crumbling wall of a building say something about the ephemeral nature of the world of entertainment. At show time people sing and dance and have a good time as the posters promise, but when the show is over the world that watched them can fall apart.

Such incongruities are, in effect, social commentaries which the photograph makes as it records the irony the photographer senses. Thus, in a scene of old buildings with all kinds of rubble on the street there is a billboard with the Anchor Bank's slogan "Your Anchor Banker Understands" and another billboard showing the rough and tough Marlboro Man lighting a cigarette (p. 141). When I snapped my shutter I wondered if what the Anchor Banker understands is that the world is crumbling around him and if the Marlboro Man knows that he may be facing a deadly disease when he lights up his cigarette.

All photographs are by definition fragments of time since they record what the world looks like at a particular moment of being. The fragment may last only 1/500 of a second, as with photographs of people in motion, or they may be of something that is perfectly still but implies the passage of time.

Among the most compelling finds in that adventure in time are photographs of children. If a statistical survey could be made of all the photographs taken around the world in any one year, I have a hunch there would be more pictures of children than of any other subject. All parents like to photograph their children almost from the day they are born, and afterward they take special pleasure in seeing how their children look at different stages of their lives. This is one kind of photograph in which the nonprofessional often does extremely well. Some of the loveliest photographs of children I have seen have been by friends who are convinced that they are otherwise terrible at taking pictures. The reason, of course, is that children are adorable to our eyes; photographs of them in tragic circumstances can break our heart, and photographs of them in happy times can give us great joy.

Perhaps children have a keener sense of what it means to fix their lives in moment of time, because they always seem delighted at the idea of having their pictures taken. I have been stopped countless times in the course of my photographic projects by children who shout, "Take my picture please!" Then they usually smile, or make funny faces, or strike a pose, while I point my

David Finn.
Brownsville.
New York. 1984

camera and snap the shutter. They never ask to see the pictures, they just want to feel that their presence has been recorded. And I often do get charming photographs from these antics, as I did with one group of children standing in the middle of a street, casting their long shadows on a late afternoon.

It is, after all, *time* that is the key dimension in all photography. The discoveries made with a camera of the world we live in, the portraits taken that enable us to see the inner spirit or respond to the outer visage of all sorts of people, the revelations on film of a part of nature we never knew existed, the panoramic scenes captured in majestic landscapes, the beauty found in naked bodies, the moments of being that are frozen

in still pictures—all these have to do with making time stop at a particular instant.

That is the miracle of photography. It is an art form that is different from other art forms in that its elements are put together by a mechanical rather than a manual process. Even when a negative is altered greatly in the printing process, the nuances can never be the same as in works produced entirely by the human hand. The unconscious elements of our being that are transmitted when the hand of an artist guides a paintbrush or a chisel cannot be transmitted through a lens. But it is an art form that captures perfectly a time when the eye sees something wonderful or something terrible, something joyful or something tragic. And it composes such sights in a way that everyone who sees a fine photograph can experience what the photographer feels at what Susan Sontag called "the privileged moment." The camera is the magical device that transmits what is going on inside the photographer's heart and mind into the hearts and minds of others.

There is still much we don't understand about what makes for greatness in a photograph. It is easier to see why Michelangelo's *David* is a great sculpture than it is to see why Weston's *Nude* is a great photograph. We stand in front of the former and are awed by the grandeur that is in the surfaces of the limbs as well as the spaces around them; we look at the latter and admire the pose, the subtlety of the tonal values, the composition, the reality it suggests. It is a different quality of greatness. The sculpture is a great thing that is *there*, before our eyes. The photograph is the transmitter of what the photographer *sees*, and the greatness *perceived* by the photographer enters our mind and becomes part of our being.

This is how looking at photographs with a knowing eye enriches our lives and extends the horizon of our experience. It enables us to share the vision of others. And above all it helps us to master the art of seeing by opening our eyes to the world around us and teaching us to visualize moments of being that when fixed on film can endure.